D1087090

4 saints in 3 acts

MANCHESTER
1824

Manchester University Press

THE
PHOTOGRAPHERS'
GALLERY

# 44th STREET THEATRE

216 West 44th Street        Phone LAckawanna 4-7135

Please Examine Your Tickets Before Leaving.     No Tickets Exchanged or Money Refunded.

*You are cordially invited to visit* **Cartier** Inc.    *5th Ave. and 52nd St.*
JEWELERS    *New York*

PEARLS    GEMS    SILVER
AS LASTING GIFTS

## ENGAGEMENT RINGS

GIFT BOOKLET
SENT ON REQUEST

SILVERWARE                  STATIONERY
Exclusive                        Playing cards
wedding     *Cartier* Inc.     Bridge
gifts                            prizes

JEWELERS

FIFTH AVENUE AND 52ND ST.

PARIS       NEW YORK       LONDON

Figures 1–2 Front and reverse of original envelope containing ticket for the 12 March 1934 performance of *Four Saints in Three Acts*

# 4 saints in 3 acts

*A snapshot of the American avant-garde in the 1930s*

Edited by Patricia Allmer and John Sears

Manchester University Press
in collaboration with
The Photographers' Gallery

Published by Manchester University Press
Altrincham Street, Manchester M1 7JA

www.manchesteruniversitypress.co.uk

in collaboration with The Photographers' Gallery
16-18 Ramillies Street, London W1F 7LW

www.thephotographersgallery.org.uk

British Library Cataloguing-in-Publication Data
A catalogue record for this book is available from the British Library

ISBN 978 1 5261 1303 0  paperback

First published 2017

Typeset by
Servis Filmsetting Ltd, Stockport, Cheshire
Printed in Great Britain by
Bell and Bain Ltd, Glasgow

Figure 3  Programme front cover for the Hartford production of
*Four Saints in Three Acts*, 1934

# FOUR SAINTS IN THREE ACTS

## HARTFORD
## 1934

# Contents

# Figures

# Notes on contributors

**Patricia Allmer** is Senior Lecturer at Edinburgh College of Art, University of Edinburgh. Her research focuses on surrealism and its heritage. It includes the monographs *Lee Miller: Photography, Surrealism, and Beyond* (Manchester University Press, 2016), *René Magritte: Beyond Painting* (Manchester University Press, 2009), edited books such as *Intersections: Women Artists/Surrealism/Modernism* (Manchester University Press, 2016), and major curatorial projects like the award-winning *Angels of Anarchy: Women Artists and Surrealism* (Manchester Art Gallery, 2009; Prestel), and *Taking Shots: The Photography of William S. Burroughs* (The Photographers' Gallery, 2014; Prestel).

**Lisa Barg** teaches in the Schulich School of Music at McGill University. Her research and teaching centre on the intersection of race, gender, and sexuality in 20th-century music, modernism, jazz, and popular music. Her work has appeared in *American Music*, *Journal of the Society of American Music*, *Journal for the American Musicological Society*, *Musical Quarterly*, *Black Music Research Journal*, and *Women and Music: A Journal of Gender and Culture*. She is currently finishing a book, *Day Dream: Billy Strayhorn, Queer History and Midcentury Jazz* (Wesleyan University Press). An article from this project, "Queer Encounters in the Music of Billy Strayhorn", was

awarded the 2014 Philip Brett Award for excellence in LGBTQ musicology.

**Christopher Breward** is Director of Collection and Research at the National Galleries of Scotland. He was previously Professor of Cultural History, Principal of Edinburgh College of Art and Vice Principal for the Creative Industries and Performing Arts at the University of Edinburgh and has published widely on the histories of fashion, masculinities, and urban cultures. Christopher also co-edits the Manchester University Press Studies in Design series.

**John Sears** worked in UK higher education for over twenty years and is now an independent scholar. His books include *Reading George Szirtes* (Bloodaxe, 2008) and *Stephen King's Gothic* (University of Wales Press, 2011), and with Patricia Allmer he co-curated and co-edited *Taking Shots: The Photography of William S. Burroughs* (2014).

**Steven Watson** is a cultural historian who is particularly interested in the group dynamics of the twentieth-century American avant-garde. He has written about the first American avant-garde, the Harlem Renaissance, and the Beat Generation. His most recent book is *Factory Made: Warhol and the Sixties* (Pantheon, 2003).

**Lucy Weir** is a specialist in modern dance and performance studies. Her research interests span the fields of live art, theatre and dance, and queer culture and gender studies (particularly masculinity). Lucy received her PhD from the University of Glasgow in 2013 and held several teaching and research fellowships before taking up her post at the University of Edinburgh.

# Foreword

The opera *Four Saints in Three Acts* was conceived by American modernist composer Virgil Thomson, in collaboration with experimental writer and dramatist Gertrude Stein, together with Eva Jessye, the first African American woman to gain international recognition as a professional choral conductor, the surrealist painter Florine Stettheimer, and director John Houseman – amongst other contributors. The production became an instant success.

*Four Saints* premiered at the Wadsworth Atheneum in Hartford, Connecticut, USA, in 1934, and later relocated to Broadway in New York for a spectacular run. With a cast consisting entirely of African American performers, a groundbreaking nonlinear structure, experimental set designs, and a "deftly simple score" (*New York Times*) the opera came to epitomise a unique avant-garde moment while also receiving broad critical acclaim.

The Photographers' Gallery is privileged to present the exhibition and to collaborate on this book *4 Saints in 3 Acts: A Snapshot of the American Avant-Garde* in considering the significance of this cultural event and – in particular – the contribution made to its success and impetus through the involvement of some of the most influential photographers of the day.

From haunting, surrealist portraits of cast and crew created by Lee Miller, portraits by photographer and patron of the Harlem Renaissance Carl Van Vechten, and eroticised nude studies by doyen of the fashion and commercial photography scene George Platt Lynes, to rare anonymous stills of the stage designs and performances shot for the White Studio, photography featured as a central component of the production's development, creative processes, and dissemination.

The importance and influence of *Four Saints in Three Acts* can be assessed, scrutinised, and examined through the various photographic records brought together for the first time here, along with a rich array of contemporary ephemera. Further contextualised through the fascinating essays, the exhibition and book offer a unique opportunity to discover anew this groundbreaking project of the American avant-garde.

We express our gratitude to the instigators and curators of this project, Dr Patricia Allmer and Dr John Sears, whose extraordinary vision and dedication brought this important exhibition and book into being. We would also like to extend our warmest thanks to the authors, lenders, and funding bodies for their generous co-operation, contributions, and enthusiasm, and to our supporters for making this ambitious project possible.

<div style="text-align: right;">

Anna Dannemann
Curator, The Photographers' Gallery

</div>

# Acknowledgements

The curators are particularly grateful for advice and support from Elizabeth Frengel of the Beinecke Library, Yale University; Annemarie van Roessel (Billy Rose Theatre Division) and Arlene Yu (Jerome Robbins Dance Division), both of the New York Public Library for the Performing Arts; Mary Yearwood of the Schomburg Center for Research in Black Culture, New York Public Library; Jennifer B. Lee of the Butler Library, Columbia University; and Morgen Stevens-Garmon of the Museum of the City of New York. Steven Watson was very generous with his time and provided us with a copy of his documentary film *Prepare for Saints*. We are very grateful for his contribution to the publication and to Lisa Barg, Christopher Breward, and Lucy Weir for their essay contributions.

We would like to acknowledge the following institutions and individuals who kindly provided images and scans of photographs and other material in their collections: The Lee Miller Archives; The Beinecke Library, Yale University; The Schomburg Center at the New York Public Library; the Butler Library at Columbia University; the Bancroft Library at University of California, Berkeley; and Josh Lynes.

Dr Allmer received awards from the TERRA Foundation and from The University of Edinburgh to pursue research in the USA.

Dr Sears was awarded a British Academy / Leverhulme small research grant to fund research and administrative elements of the project. We are also very grateful to the British Association of American Studies for awarding funding to support the exhibition events programme.

Thanks are due for advice, comment, translations, suggestions, and support to Maurice Bottomley, David Brittain, Raphaël Costambeys-Kempczynski, Claire Thoury, and the staff at The Photographers' Gallery and at Manchester University Press.

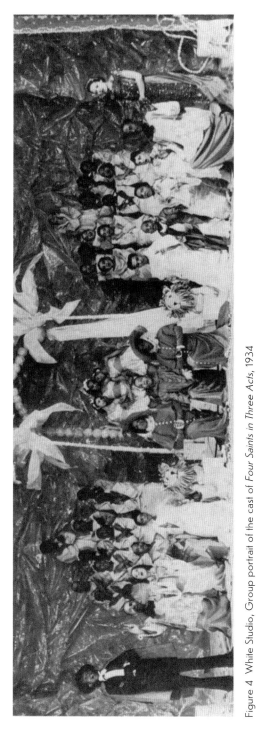

Figure 4 White Studio, Group portrait of the cast of *Four Saints in Three Acts*, 1934

# Introduction

*Patricia Allmer and John Sears*

Well anyway we all went away and as we came down-stairs there was an elderly colored man and he came up to me and said Miss Gertrude Stein and I said yes and he said I am (I have forgotten the name), I was the first music teacher of Mr Matthews who sang Saint Ignatius and I wanted to say how do you do to you and I was very touched.[1]

*4 Saints in 3 Acts: A Snapshot of the American Avant-Garde* explores photography's roles in representing, recording, and contributing to the social and aesthetic impact of the remarkably popular 1934 American opera *Four Saints in Three Acts*. Many books and essays (some of them discussed below and in the following chapters) have examined the history of this opera and its contexts, from a variety of critical perspectives, and focused in different ways on the multiple collaborations, innovations, impacts, and legacies that *Four Saints* mobilised and bequeathed. The event sustains readings attuned to ethnic identities (like the review in *The Theatre*, 25 April 1934, which notes the prominent Jewish contribution to the show),[2] and offers a

1 Gertrude Stein, *Everybody's Autobiography* (London: Virago Press, 1985), pp. xxv–xxvi.
2 See www.jta.org/1934/04/25/archive/the-theatre-18.

Figure 5 Cast list from *Four Saints in Three Acts* programme, 44th St Theatre, New York, 1934. In the Hartford performance St Chavez was played by Embry Bonner, St Plan by George Timber, St Eustace by Randolph Robinson. The New York male saints differed, numbering ten, rather than the original six from which Harold Des Verney dropped out. Helen Dorody Moore joined the New York cast as an additional female saint

productive text for queer theoretical readings like that proposed by Nadine Hubbs, exploiting the opera's "blank screen quality, subject to viewers' projections".[3]

A key group of photographers was involved in its documentation and recording. This involvement has received little critical attention. These photographers include Lee Miller ("the most stylish photographer in town"),[4] Carl Van Vechten, George Platt Lynes, and the (often anonymous) press photographers working for the White Studio. They portrayed several of the cast, crew, and production team members for programmes and other promotional material, photographed performances and stage settings, and recorded some of the ways *Four Saints* impacted on and was reflected in the wider culture of New York in 1934. Miller was contracted (through her relationship with stage director John Houseman) to photograph the cast. Van Vechten, renowned for his photography of prominent African Americans, also produced a series of cast portraits.

## Four Saints in Three Acts

Written by Gertrude Stein (1874–1946) and composed by Virgil Thomson (1896–1989) in Paris, between May and December 1927, *Four Saints in Three Acts* premiered with an all-African American cast on 7 February 1934, at the Wadsworth Atheneum in Hartford, Connecticut, marking the opening there of the first exhibition in the USA of works by Stein's close friend Pablo Picasso. Thomson engaged his lover, the painter Maurice Grosser (1903–86), to write the opera's scenario. The cast members were largely gathered from the nightclubs, music halls, and choirs of Harlem under the guidance of journalist Edward Perry (1908–55), who would lead the United Services Organisations touring unit of *Porgy and Bess* during the Second World War, and Jimmy Daniels (1908–84), an entrepreneur and nightclub performer who would later MC at Bon Soir, which famously hosted Barbra Streisand's first New York performance in 1960. The cast was directed by Romanian-born actor John Houseman (1902–88), choreographed by future Royal Ballet director Frederick Ashton (1904–88), and trained and conducted by the only

3 Nadine Hubbs, *The Queer Composition of America's Sound: Gay Modernists, American Music, and National Identity* (Berkeley and Los Angeles: University of California Press, 2004), p. 20.
4 Virgil Thomson, *Virgil Thomson* (New York: Da Capo, 1967), p. 238.

Figure 6 Record sleeve with White Studio photograph of 1934 performance, Virgil Thomson (conducts) *Four Saints in Three Acts*, recorded June 1947 (RCA)

African American involved organisationally, choir-leader Eva Jessye (1895–1992), whose choir supported the performers, and, like several of them, would go on to appear in Gershwin's *Porgy and Bess* in 1935.

Jessye, born in Coffeyville, Kansas, and a graduate of Western University in Kansas City and of Langston University in Oklahoma, was a major figure in African American musical history, with a distinguished teaching, performing, and conducting career – "the first black woman in America to succeed as a choral director", Steven Watson notes in his definitive history of the opera, *Prepare for Saints*.[5]

5 Steven Watson, *Prepare for Saints: Gertrude Stein, Virgil Thomson, and the Mainstreaming of American Modernism* (New York and Toronto: Random House, 1998), p. 244.

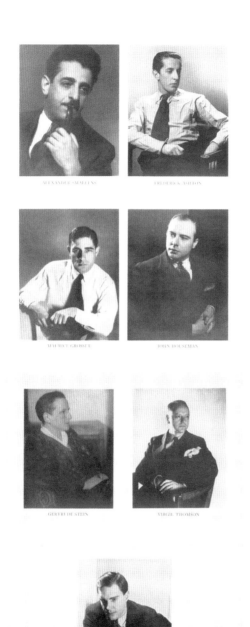

Figures 7–8  44th St Theatre programme, crew photographs (all by Lee Miller, except Gertrude Stein, by Man Ray)

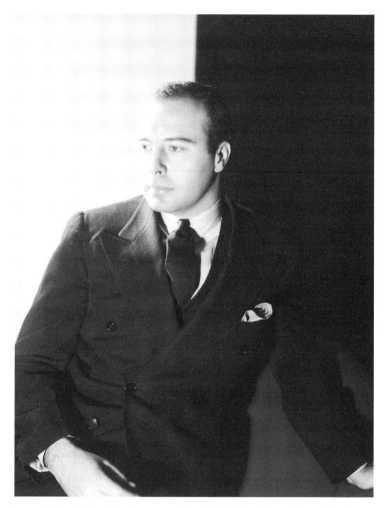

Figure 9 Lee Miller, John Houseman, New York Studio, New York, ca. 1933

She taught music in Oklahoma and Baltimore, before moving to New York in 1926 and establishing the Dixie Jubilee Singers, later renamed the Eva Jessye Choir. She acted in stage productions of *Porgy and Bess* and *Showboat*, and appeared in several films including Carl Lerner's *Black Like Me* (1964). Recounting the experience of working on *Four Saints* to Watson, she emphasised the opera's strange and estranging difference, and her and her choir's accommodation of it:

> With this opera we had to step on fresh ground, something foreign to our nature completely. Not like *Porgy and Bess* that came the next

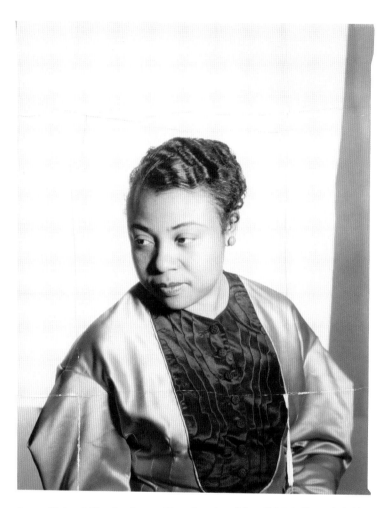

Figure 10 Lee Miller, Eva Jessye, Choir Director of *Four Saints in Three Acts*, New York Studio, New York, ca. 1933

year – that was our inheritance, our own lives. But what did we know about the minds of Gertrude Stein and Virgil Thomson? We really went abroad on that.[6]

The surrealist artist Florine Stettheimer (1871–1944) designed, with the assistance of designer and actor Kate Drain Lawson (1894–1977), the stage settings and costumes (discussed in Christopher Breward's essay), famously making extensive use of lace and sky-blue cellophane for both, causing problems with New York City fire

6 Quoted in Watson, *Prepare for Saints*, p. 245.

safety rules. Stettheimer also worried that her colour-schemes would clash with the black skins of the performers, who, she seriously proposed, might be painted white or silver to mitigate this.[7]

Critical consensus sees the opera as an event that combined in a unique configuration a key set of aesthetic, social, cultural, and political dimensions, producing a powerfully syncretic, if "putatively nonsensical", work.[8] Most critics, and the published commentary of many of those who worked on the opera, agree about this syncretic dimension, drawing attention to the productive dynamisms and tensions resulting from sometimes difficult collaborations across media and disciplinary, as well as national, class, racial, and sexual, boundaries. Various largely complementary critical perspectives emerge in these writings. Barbara Webb, for example, reads the racial politics of the opera's staging as an "intersection of Steinian modernism and black performance", and begins with an assertion of the syncretic distortion in *Four Saints* of the conventional operatic relation between words and music – it is, she argues, "a work in which words served the usual function of music, not telling a story or communicating meaning in a traditional fashion, but primarily *sounding*".[9] Webb goes on to describe the opera's form as "a series of tableaux in which characters identified as Spanish saints were seen chatting, picnicking, marching in a processional, and painting giant Easter eggs [offering] snapshots of existence rather than traditional scenes of action".[10] Dramatic action, she suggests, is replaced by serial presentation of "snapshots". Her evocation of photography as metaphor affirms its importance for grasping the aesthetic and cultural significance of the moment of *Four Saints*.

*Four Saints* developed out of meetings between Gertrude Stein and Virgil Thomson in Paris that probably began in January 1926. Their correspondence, archived at Yale's Beinecke Library and edited and published by Susan Holbrook and Thomas Dilworth, records an extraordinary and sometimes stormy relationship of collaboration and friendship. Stein agreed, in the early summer of 1927, to collaborate with Thomson on an opera, a genre new to her. Thomson's theory of the opera, he later recollected, grounded it in

---

7 See Watson, *Prepare for Saints*, pp. 206–8.
8 Hubbs, *The Queer Composition of America's Sound*, p. 23.
9 Barbara Webb, "The Centrality of Race to the Modernist Aesthetics of Gertrude Stein's *Four Saints in Three Acts*", *Modernism/Modernity*, Vol. 7 No. 3 (2000): 447–69; 447.
10 Webb, "The Centrality of Race", 449.

European musical traditions couched explicitly in terms evoking a specifically modernist interest in the serial and "primitive":

> I thought that to do anything serious about the opera in a new language, one needed to go back to the more primitive and strong forms. I thought Italian opera seria of the seventeenth and eighteenth centuries was exactly the sort of form one could do something with.[11]

This aesthetic and ideological matrix of "new language" and "going back" to "more primitive and strong forms" characterised the productively contradictory dynamics of the forms of modernism with which Stein and Thomson, in different but complementary ways, engaged.

Stein wrote in her 1934 lecture "Plays" of two formative influences on her *Four Saints* libretto (which was first published in Eugéne Jolas's journal *transition* in late 1928). Both derive from commerce on Parisian streets: a shop window on the Rue de Rennes featuring "a rather large porcelain group" depicting "a young soldier taking his helmet off and giving alms to a beggar", and a photography "place" on the Boulevard Raspail where

> They take a photograph of a young girl dressed in the costume of her ordinary life and little by little in successive photographs they change it into a nun. These photographs are small and the thing takes four or five changes but at the end it is a nun [...]. For years I stood and looked at these when I was walking and finally when I was writing Saint Theresa in looking at these photographs I saw how Saint Theresa existed from the life of an ordinary young lady to that of the nun.[12]

A particular form of serial commercial photography, closely tied to practices of mourning and memorialisation, is thus an important source of the completed text Stein sent to Thomson in June 1927. "By mid-December", Thomson wrote in his autobiography, "I had a score consisting of the vocal lines and a figured bass, a score from which I could perform."[13] This score worked productively with

---

11  Thomson to Thomas Dilworth, 3 February 1981; quoted in *The Letters of Gertrude Stein and Virgil Thomson: Composition as Conversation* (ed. Susan Holbrook and Thomas Dilworth) (Oxford: Oxford University Press, 2010), p. 9.

12  Gertrude Stein, "Plays", in Patricia Meyerowitz (ed.) *Look at Me Now and Here I Am: Writings and Lectures 1911–1945* (Harmondsworth: Penguin, 1971), pp. 59–83: p. 82.

13  Thomson, *Virgil Thomson*, p. 104.

Stein's text, famously interpreting her stage instructions so literally as to incorporate them unchanged into the sung libretto. Thomson's decision to use African American singers defines the importance of *Four Saints*. Alan Rich cites a conversation with him in 1965:

> During the Thirties we liked to end our evenings up at one of the night clubs in Harlem; it was the thing to do in those days. More and more it struck me as inevitable that the way Negro singers produced their words, and the complete naturalness of their style, was what we wanted for *Four Saints*. We had the idea that professional white singers might make fun of the verses, and we were probably right. The Negroes we got together for the first performance not only accepted everything; by the end of a week's rehearsals they were actually talking like Stein when they were off the stage.[14]

*Four Saints* was not the first major artwork to employ an all-African American cast. Numerous minstrel shows and black theatrical productions precede it. Harry Lawrence Freeman's (1869–1954) opera *Voodoo*, written in 1914, eventually premiered with an all-African American cast at Palm Garden on West 52nd St in New York in September 1928, with a performance broadcast on WGBS radio on 28 May.[15] Scott Joplin's *Treemonisha* was performed as a read-through with its composer on piano at Harlem's Lincoln Theatre in 1915. Langston Hughes recollected seeing *Shuffle Along*, a Broadway musical review, in 1921, and Emily Bernard notes two 1898 productions, *Clorindy: The Origin of the Cakewalk* and *A Trip to Coontown*.[16] In cinema, King Vidor's *Hallelujah* (1929), an early talkie, had been filmed in and around Memphis with an all-black cast including Daniel Haynes, who had understudied for Paul Robeson, and Eva Jessye's Dixie Jubilee Singers. Jessye later recounted how Vidor's cast "put in little touches, Negro mannerisms, phrases that could be written by no white man".[17] What made *Four Saints* unique in this

14 Alan Rich, "*Four Saints*: Humanity is the Key Word", *Hi-Fidelity* (February 1965): 70–1.

15 See Elise Kuhl Kirk, *American Opera* (Chicago: University of Illinois Press, 2001), pp. 186–8. *Voodoo* was revived in 2015 at Columbia University's Miller Theatre by the Harlem Opera Theatre with Morningside Opera and The Harlem Chamber Players.

16 Emily Bernard, *Carl Van Vechten & The Harlem Renaissance: A Portrait in Black and White* (Hew Haven: Yale University Press, 2012), p. 29.

17 Greg Akers, "King Vidor's *Hallelujah*", *Memphis: The City Magazine* (28 August 2014), at http://memphismagazine.com/culture/arts/king-vidors-hallelujah/ (accessed 29 February 2016).

tradition of African American performance was its thematic concern with the lives of Spanish saints, a topic wholly distinct from the conventional use (as in *Voodoo* and *Hallelujah*) of African Americans to perform stereotypically black American narratives.

## The cast

The African American cast, mainly comprising (Steven Watson asserts) "anonymous singers in choruses and church choirs",[18] included performers gleaned from the classical music world of the Harlem Renaissance. Biographical details of many of them are scarce.

Baritone Edward Matthews, born in Ossining, New York, in 1904, played St Ignatius of Loyola, and had the greatest subsequent success of the cast members. A graduate of Fisk University, where he later taught, he had toured Europe with the Fisk Jubilee Singers in 1927–28, and would play Jake in Gershwin's *Porgy and Bess* in 1935. He performed "St Ignatius' Vision" from *Four Saints* at a recital at West 43rd St's Town Hall in December 1934, with Virgil Thomson accompanying on piano.[19] Frances Moss Mann notes his performance at the climax of the 16th annual convention of the National Association of Negro Musicians at the Wadleigh High School Annex in August 1935.[20] He gave his first Harlem recital at Salem Church in December 1936, and was at that time a regular feature of WABC's Capitol Radio Family.[21] In 1938–39 he toured Latin America for five months of concert and radio performances.[22] He sang "Ballad for Americans" at the New York World's Fair in 1940 and at the Negro Song Festival in 1941.[23] In December 1945 he gave a recital of lieder and "Afro-American folksongs – work and religious" – again at Town Hall.[24] His sister Inez Matthews (1917–2004) sang with him as

18 Watson, *Prepare for Saints*, p. 315.
19 Anon., "To Give Recital", *The New York Amsterdam Star-News* (1 December 1934): 4.
20 Frances Moss Mann, "Music Notes: 200 Delegates at Convention", *The New York Amsterdam Star-News* (31 August 1934): 4.
21 Anon., "Edward Matthews in First Harlem Recital", *The New York Amsterdam Star-News* (28 November 1936): 6.
22 Anon., "Edward Matthews Is Tops in Tropics", *The New York Amsterdam Star-News* (26 November 1938): 20.
23 Anon., "Ed Matthews in Song Fete", *The New York Amsterdam Star-News* (10 May 1941): 17.
24 Anon., "In Rental", *The New York Amsterdam Star-News* (15 December 1945): 27.

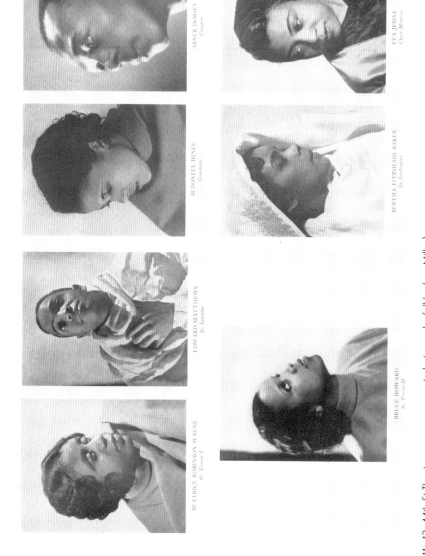

ABNER DORSEY
*Compere*

ALTONELL HINES
*Comminere*

EDWARD MATTHEWS
*St. Ignatius*

BEATRICE ROBINSON WAYNE
*St. Teresa I*

EVA JESSYE
*Choir Mistress*

BERTHA FITZHUGH BAKER
*St. Settlement*

BRUCE HOWARD
*St. Teresa II*

Figures 11–12  44th St Theatre programme, cast photographs (all by Lee Miller)

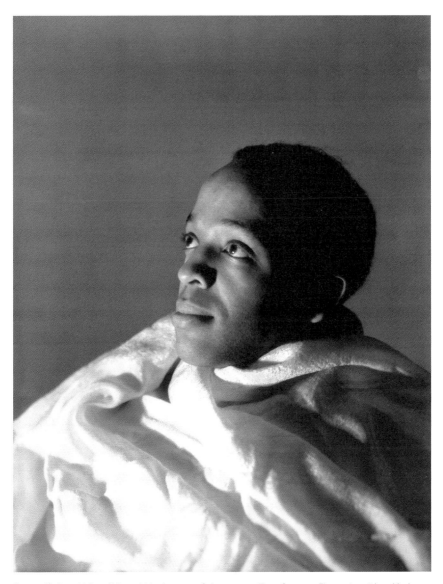

Figure 13  Lee Miller, Edward Matthews as St Ignatius in *Four Saints in Three Acts*, New York Studio, New York, ca. 1933

St Theresa I in the 1952 Broadway Theatre revival of *Four Saints*, and was the performance double for Ruth Attaway (and sang Serena) in Otto Preminger's 1959 film of *Porgy and Bess*. Edward Matthews was killed in a car accident in Woodbridge, Virginia, in 1954 (a report in the *New York Amsterdam News* of 28 July 1934 notes, strangely, that

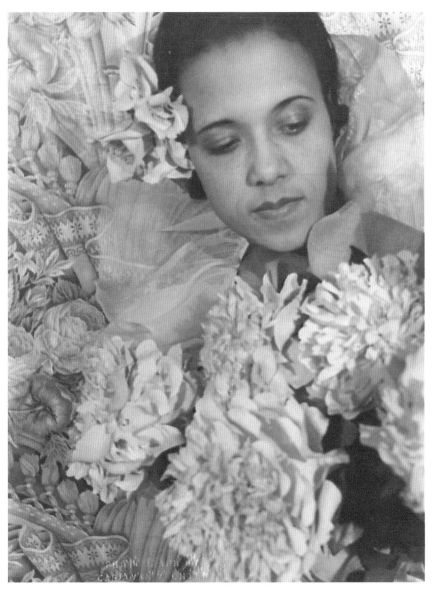

Figure 14 Carl Van Vechten, Altonell Hines as Commère in *Four Saints in Three Acts*, 9 March 1934

"it was erroneously rumored two weeks ago that Mr Matthews was killed in an accident").[25]

25 Frances Moss Mann, "Mwalimu School Gets New Teacher", *The New York Amsterdam Star-News* (28 July 1934): 7.

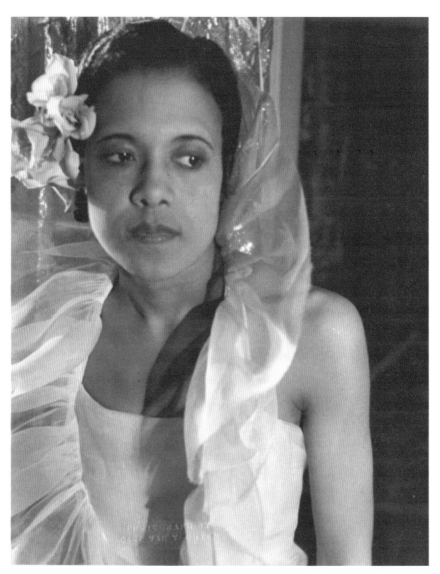

Figure 15  Carl Van Vechten, Altonell Hines as Commère in *Four Saints in Three Acts*, 9 March 1934

Matthews married Altonell Hines, who played the Commère. Hines was born in Norfolk, Virginia, in 1904, and graduated from Livingstone College and with a Master's in Music Education from Columbia Teaching College. She too would sing in the first stage production of *Porgy and Bess* in 1935, and in the 1952 Broadway Theatre revival of *Four Saints*. In January 1941 she was noted by Dan

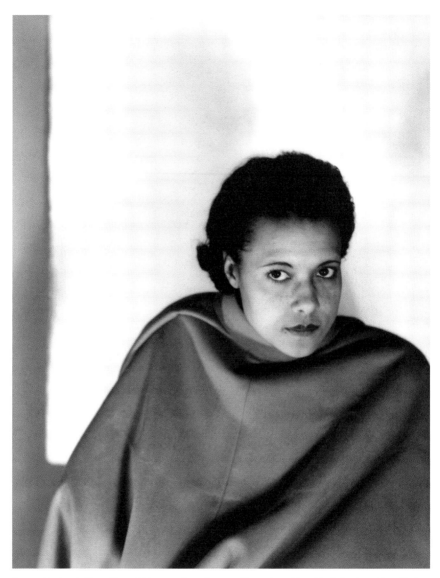

Figure 16  Lee Miller, Altonell Hines in *Four Saints in Three Acts*, New York Studios, New York, ca. 1933.

Burley as "getting plenty radio work" [*sic*] but "rehearsing with a quintet" and wanting "to return to singing again".[26] The quintet was the Sophistichords, who played "Salon Swing" coffee concerts at

26 Dan Burley, "Back Door Stuff: Round Harlem for the Lowdown", *The New York Amsterdam Star-News* (18 January 1941): 20.

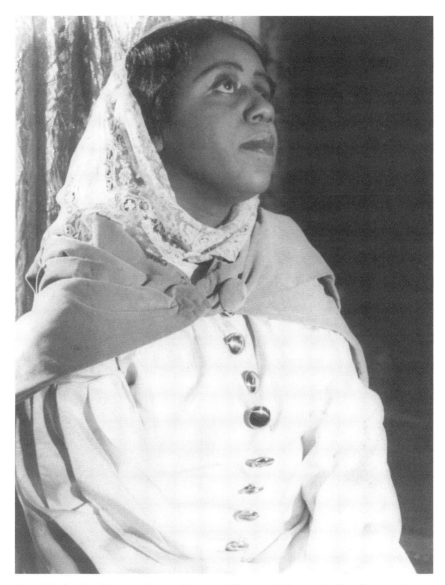

Figure 17 Carl Van Vechten, Beatrice Robinson-Wayne as St Theresa I in *Four Saints in Three Acts*, New York, 9 March 1934

MoMA, the second of which included a performance of *Four Saints*.[27] Hines died in New York in 1977.

27 Anon., "Coffee Concerts at Modern Art Museum", *The New York Amsterdam-Star News* (26 April 1941): 20; anon., "Sophisticated Sophistichords", *The New York Amsterdam Star-News* (10 May 1941): 17.

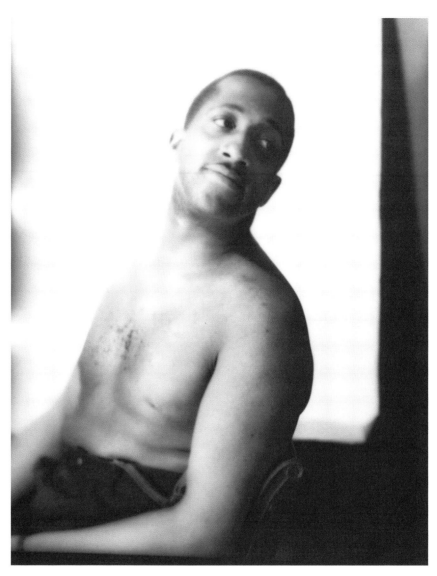

Figure 18  Lee Miller, unidentified performer, *Four Saints in Three Acts*, New York Studio, New York, ca. 1933

Soprano and former radio performer Beatrice Robinson Wayne, who was (Watson notes) 33 at the time of her audition in December 1933, played St Theresa I. She sang with Virgil Thomson on piano in a recital at the West 135th St YMCA in February 1935, and later performed (along with Edward Matthews and Charles Holland from the original cast) in the 1947 recording of *Four Saints* released by

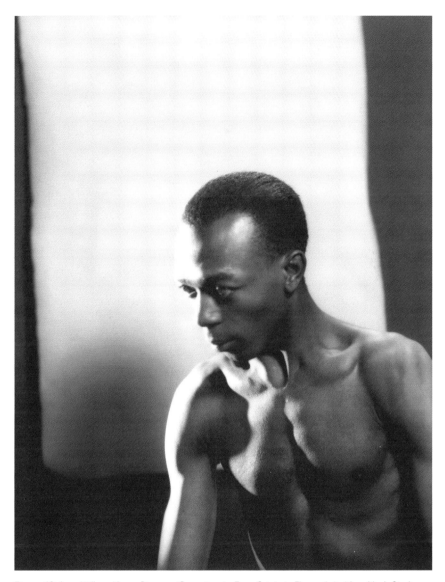

Figure 19  Lee Miller, Abner Dorsey, Compère in *Four Saints in Three Acts*, New York Studio, New York, ca. 1933

RCA and conducted by Virgil Thomson, "slightly past her prime", according to reviewer Jed Distler.[28]

28 Anon., "Arrange Program", *The New York Amsterdam Star-News* (23 February 1935): 6; "Thomson: Four Saints" review by Jed Distler, *Classics Today* (undated) at www.classicstoday.com/review/review-14621/ (accessed 1 March 2016).

The Compère was played by Abner Dorsey (1900–56), a bass-baritone and former vaudevillean performer. He appeared in three further Broadway musicals between 1936 and 1938, and then in performances by the New York Philharmonic of William Grant Still's *And They Lynched Him on a Tree* in 1940 and 1941. Of Bruce Howard, the contralto who played St Theresa II, little is known – Watson records that, after *Four Saints*, she "found more musical opportunities abroad where, she declared, 'I'm a black princess!'"[29] She appeared subsequently in Broadway revues and musicals including *Virginia* (1937), *The Hot Mikado* (1939, again with an all-black cast), and *Call Me Mister* (1946–48). She gave a performance of *Four Saints* for the Bethesda Missionary Society at New Rochelle, Westchester, in June 1942.[30]

Tenor Embry Bonner, who played St Chavez in the Hartford performances (to be replaced by the more suitably Jewish Leonard Franklyn in the New York performances), appears in a 1964 photograph by Bill Anderson of the Harold Jackman Memorial Committee, at the Playboy Club in New York.[31] Prior to appearing in *Four Saints*, he "gave a superlative performance" of songs by Wagner and Schubert at a recital at Grace Congregational Church in January 1934.[32] Franklyn appeared, in November 1939, as guest soloist alongside Dorothy Maynor with the Boston Symphony Orchestra at Carnegie Hall.[33]

Little is known of the rest of the Hartford performers. Bertha Fitzhugh Baker, who had appeared with Paul Robeson in *Showboat* at the Casino Theatre in 1932, is amongst those honoured at the 2009 Carnegie Hall "Celebration of the African American Cultural Legacy", curated by Jessye Norman. She sang accompanying Elizabeth Giddings "with fervor, fullness, depth and passion" at a recital in Yonkers in January 1934,[34] and, in 1942, was teaching "voice and piano at her 41 Convent Avenue studio" and gave a recital at Bethel AME Church.[35] Thomas Anderson (St Giuseppe), who was born in Pasadena in 1905 and died on 12 January 1996

29 Watson, *Prepare for Saints*, p. 315.
30 Anon., "Westchester", *The New York Amsterdam Star-News* (13 June 1942): 20.
31 The photograph is reproduced in Dorothy West, *Where the Wild Grape Grows: Selected Writings 1930–1950* (ed. Verner D. Mitchell and Cynthia Davis) (Amherst: University of Massachusetts Press, 2005).
32 Frances Moss Mann, "Music News: Casks Bonds Presents Commendable Program", *The New York Amsterdam Star-News* (31 January 1934): 16.
33 Bill Chase, "All Ears", *The New York Amsterdam Star-News* (25 November 1939): 21.
34 Ibid.
35 Anon., "Music Notes", *The New York Amsterdam Star-News* (9 May 1942): 10.

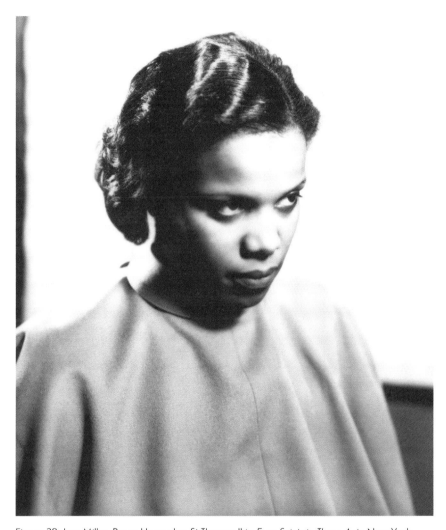

Figure 20  Lee Miller, Bruce Howard as St Theresa II in *Four Saints in Three Acts*, New York Studio, New York, ca. 1933

in New Jersey, appeared in later Broadway productions including an adaptation of Richard Wright's *Native Son* (1942). He worked in radio in New York and Chicago during the War, and was assistant director of Orson Welles's all-black production of *Macbeth* in 1936; he managed a United Service Organisations USO touring troupe in Japan and the Philippines in 1946.[36] Of Kitty Mason (interviewed in 1984 by Steven Watson), Charles Spinnard, Marguerite Perry

36 Anon., "Thomas Charles Anderson", *Variety* (11 March 1996): 60.

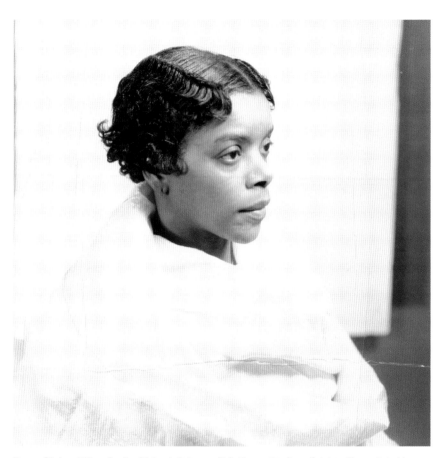

Figure 21 Lee Miller, Bertha Fitzhugh Baker as St Settlement in *Four Saints in Three Acts*, New York Studio, New York, ca. 1933

(who was born in Denver in 1913 and died in Hartsel, 2007), Flossie Roberts, Edward Batten, Florence Hester, and George Timber, few traces remain. The Negro Art Singers, including some members of the *Four Saints* and *Porgy and Bess* casts, gave several publicly noted performances in late 1938, including one at New York's New School for Social Research on 12 November.[37] Paul Smellie, a male saint in the Hartford production, was commissioned in the US Army Air Forces Officers Candidate School at Miami Beach in 1944, having previously studied at the College of the City of New York and travelled extensively as a Boy Scout in Latin America and Europe.[38]

37 Anon., "Music Notes", *The New York Amsterdam Star-News* (12 November 1938): 23.
38 Anon., "Commissioned", *The New York Amsterdam News* (27 May 1944): 4A.

The dancers included three women from the Grace Giles Dancing School. Marble Hart subsequently played Dawn in a City College production of Shakespeare's *A Midsummer Night's Dream* in April 1935, and danced in a charity event at the Lido Ballroom in Harlem in June 1936.[39] Melba Love, a graduate of Wadleigh High School, died in West Palm Beach, Florida, August 1934. The male dancers, Floyd Miller, Billie Smith, and Maxwell Baird, appear in George Platt Lynes's photograph, with Frederick Ashton.

After the opening shows in Hartford, the ensemble moved to the 44th St Theatre in New York,[40] making *Four Saints* the first opera to be staged on Broadway, and then in April 1934 to the Empire Theatre on 40th and Broadway. Later in 1934 it was performed at the Auditorium Theatre in Chicago, in the attendance of Stein, who was beginning her immensely successful American lecture tour with her partner Alice B. Toklas. African American reviewer George W. Streater described *Four Saints* as "a strange mixture of sacred and vulgar sequences. At times one feels 'churchy', and at times one wants to guffaw. But at no time is one quite certain what it is all about."[41] An earlier attempt to stage the opera in 1930, in German (and presumably not with an African American cast), initiated by the poet Edwin Denby at the Hessisches Landestheater in Darmstadt, had fallen through – Thomson records a letter from Denby of 1 May 1930, stating that "The chances are pretty black".[42]

## Image/voice

Reviewers of the original performances noted the quality of the singing. Robert Garland, writing in the *New York World* on 21 February 1934, commented, for example, that *Four Saints* "is sung as it should be sung, by an all-Negro cast that distinguishes itself by its clear enunciation, its full-throated singing, its evident enjoyment".[43] Marvel

39 Anon., "Shakespearean Comedy is Slated for April 6th ", *The New York Amsterdam Star-News* (30 March 1935): 10; anon., "500 Present at Club's Formal", *The New York Amsterdam Star-News* (6 June 1936): 7.
40 The subsequent show at the 44th St Theatre was George Sklar and Albert Maltz's *Peace on Earth*, starring Walter Vonnegut, uncle of the novelist Kurt Vonnegut.
41 George W. Streator, review of *Four Saints in Three Acts*, *Crisis*, 4 (1934): 103.
42 Thomson, *Virgil Thomson* , pp. 147–8.
43 Robert Garland, "Offering at 44th St, Though Unintelligible, Is Dignified by Singing of Its Negro Cast", *New York World* (21 February 1934) (cutting in Carl Van Vechten Scrapbooks).

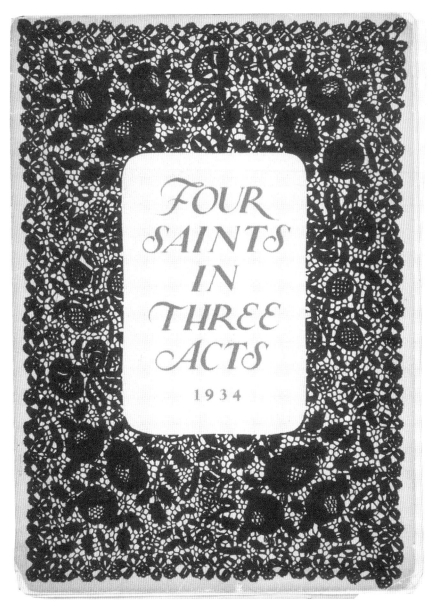

Figure 22  44th St Theatre brochure, New York, 1934

Cooke wrote that the cast of the 1941 revival, largely that of the origi-
nal performances, sang "with remarkable clarity of diction".[44] Virgil

44 Marvel Cooke, "'Four Saints' at Town Hall", *The New York Amsterdam Star-News*
(31 May 1941): p. 21.

**4 SAINTS IN 3 ACTS**

GERTRUDE STEIN

**FORTY-FOURTH STREET THEATRE**

Figure 23  44th St Theatre programme, New York, 1934

Thomson's autobiographical and epistolary comments on the opera and his desire to cast African American singers also focus mainly on questions of vocal expression, while unconscious allusions to racial difference pepper his prose – like the effect of his idiosyncratically limited choice of orchestral accompaniment to the Hartford

# 4 · SAINTS · IN · 3 · ACTS

## THE · EMPIRE · THEATRE

Figure 24 Empire Theatre programme, New York, 1934

production, which, he notes, "gave the work a color like that of no other".[45] "My negro singers are, after all, purely a musical desideratum", he wrote to Stein on 30 May 1933, "because of their rhythm,

45 Thomson, *Virgil Thomson*, p. 224.

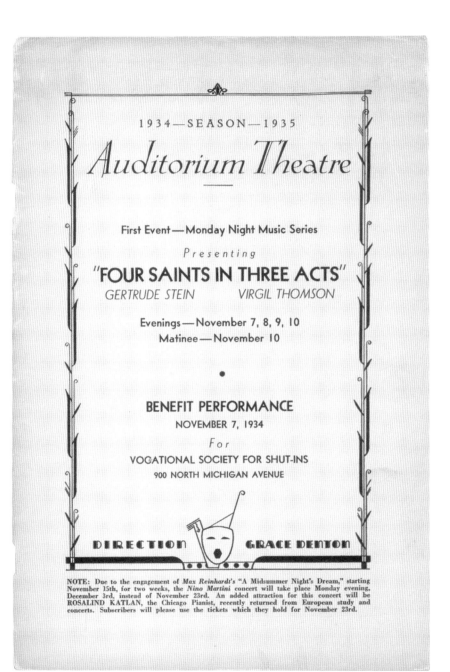

1934—SEASON—1935

# Auditorium Theatre

First Event—Monday Night Music Series

*Presenting*

## "FOUR SAINTS IN THREE ACTS"

*GERTRUDE STEIN          VIRGIL THOMSON*

Evenings—November 7, 8, 9, 10
Matinee—November 10

•

### BENEFIT PERFORMANCE

NOVEMBER 7, 1934

*For*

VOCATIONAL SOCIETY FOR SHUT-INS
900 NORTH MICHIGAN AVENUE

DIRECTION          GRACE DENTON

NOTE: Due to the engagement of *Max Reinhardt's* "A Midsummer Night's Dream," starting November 15th, for two weeks, the *Nino Martini* concert will take place Monday evening, December 3rd, instead of November 23rd. An added attraction for this concert will be ROSALIND KATLAN, the Chicago Pianist, recently returned from European study and concerts. Subscribers will please use the tickets which they hold for November 23rd.

Figure 25  Auditorium Theatre programme, Chicago, 1934

their style and especially their diction".[46] His pride in his choice of performers is clear: "My singers, as I have wanted, are negroes, & you cant [*sic*] imagine how beautifully they sing", he wrote to Stein on 6 December 1933.[47] A passage from his autobiography (quoted without comment by Holbrook and Dilworth) elaborates:

> Not only could they enunciate and sing: they seemed to understand because they sang. They resisted not at all Stein's obscure language, adopted it for theirs, conversed in quotations from it. They moved, sang, spoke with grace and with alacrity, took on roles without self-consciousness, as if they were the saints they said they were. I often marveled at the miracle whereby slavery (and some cross-breeding) had turned them into Christians of an earlier stamp than ours, not analytical and self-pitying or romantic in the nineteenth-century sense, but robust, outgoing, and even in disaster sustained by inner joy.[48]

Thomson's language here (his autobiography was published in 1967) betrays much about the complexities and problems of the racial codes of language and representation deployed by his generation. His alertness to the intensity of the performances relates closely to the photographic portraits and their problematic depiction less of individuals than of performances, or of visualisations of saintly ideals (a theme discussed in John Sears's essay).

Carl Van Vechten was a long-term friend of Stein and a well-known supporter of African American advancement, despite the notoriety surrounding the publication of his 1926 novel unfortunately titled *Nigger Heaven*. Emily Bernard comments on the dynamic ambiguity of his "passionate attachment" to black Americans and their cultures: "He warned against the evils of condescending whites at the same time as he offered up black bodies for the enjoyment of white spectators."[49] He attended the opening night in Hartford, Connecticut, in February 1934, and also commented on the voices of the performers,[50] and wrote to Stein on 8 February 1934:

> The Negroes are divine, like El Grecos, more Spanish, more Saints, more opera singers in their dignity and *simplicity* and extraordinary

46 Ibid., p. 231.
47 *The Letters of Gertrude Stein and Virgil Thomson* (ed. Holbrook and Dilworth), p. 221.
48 Thomson, *Virgil Thomson*, p. 239, quoted by Holbrook and Dilworth, *The Letters of Gertrude Stein and Virgil Thomson*, p. 222.
49 Bernard, *Carl Van Vechten & The Harlem Renaissance*, p. 23, p. 72.
50 For a detailed discussion of the controversy around Van Vechten's novel, see Bernard, *Carl Van Vechten & The Harlem Renaissance*, pp. 107–90.

plastic line than *any* white singers could ever be. And they enunciated the text so clearly you could understand every word.[51]

A few weeks later, on 12 March, Van Vechten sent Stein copies of "photographs I made especially for you of the electric signs over the 44th Street Theatre", depicting Stein's name in lights;[52] and then on 29 March he sent her "my photographs of 3 of the Saints – the costumes are still Florine Stettheimer's, but the décor in these photographs of the lilies, peonies etc. are by C. V. V.".[53] Stein responds in her letter postmarked 11 April:

> The photographs are wonderful I have never seen such photographs, and the background what wonderful stuffs and paper and flowers, and the black one of Saint Ignatius, it has completely upset everybody, everybody wants to see them, I do honestly think they are the finest photographs I have ever seen.[54]

One might ponder here what it was about Van Vechten's photograph of Edward Matthews, whom Stein names in his role as St Ignatius, that so "upset everybody" while sustaining the superlative public interest Stein claims. Stein (her name inscribed in Broadway neon) and costume and stage designer Florine Stettheimer bear names in this correspondence; the performers do not.

The emphasis in Stein's comment is on the spectacle, rather than the people, recorded in Van Vechten's photographs. Van Vechten's and Thomson's accounts focus, instead, on performance and voice, or clarity of "enunciation" – what Roland Barthes calls "the *grain* of the voice", "that apex (or that depth) of production where the melody really works at the language"[55] – the "grain" metaphor evoking, of course, the grainy monochrome photograph. Amid this attention to vocal and visual qualities, the actual identities of the performers are already in danger of erasure – selves are in the process of being redefined as utterances, traces of "the body in the voice as it sings".[56] If the photographs, for Stein, present a "wonderful" visual spectacle,

---

51  Carl Van Vechten to Gertrude Stein, 8 February 1934. In *The Letters of Gertrude Stein and Carl Van Vechten 1913–1946* (ed. Edward Burns) (New York: Columbia University Press, 2013), p. 295.

52  Ibid., pp. 301–2.

53  Ibid., p. 305.

54  Ibid., p. 306.

55  Roland Barthes, "The Grain of the Voice", in *Image-Music-Text* (ed. Stephen Heath) (New York: Hill and Wang, 1977), pp. 181–2.

56  Ibid., p. 188.

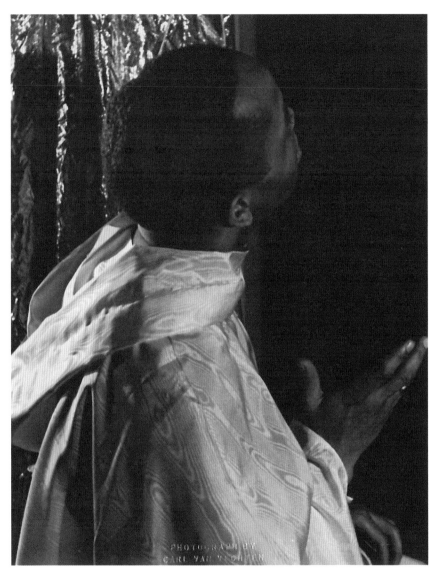

Figure 26  Carl Van Vechten, Edward Matthews as St Ignatius in *Four Saints in Three Acts*,
9 March 1934

the voices, for Van Vechten and Thomson, render the performing
and photographed subjects strangely invisible.

The photographic portraits of the African American singers thus
assume huge significance as counter-histories to this tendency –
all too familiar – to render African American historical presence
invisible. They powerfully affirm Henry Louis Gates's insight that

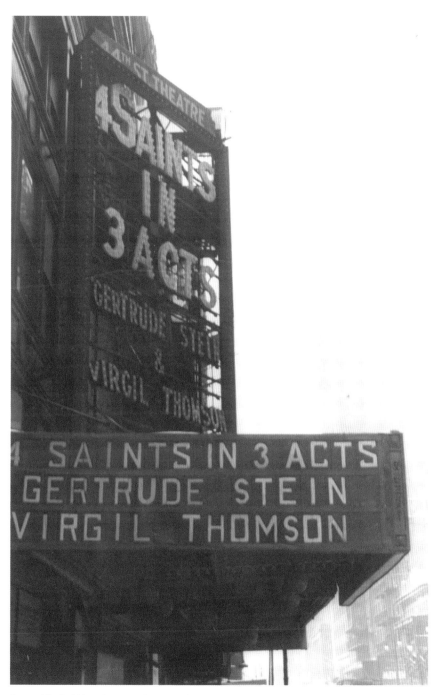

Figure 27  Carl Van Vechten, Gertrude Stein's name in electric light over 44th St Theatre, New York, March 1934

"Voice, after all, presupposes a face".[57] And the faces we see in these portraits belonged to people working and performing in Harlem and on Broadway in the 1930s. The contexts from which they emerged – teaching music, performing classical and other works in choirs and orchestras, in churches and dance halls, small theatres and music houses – are part of a complex weave of cultural practices embedded in the broader fabric of the culture industries in the crucial period of modernist African American cultural production and self-definition that was, in 1934, coming to an end – the Harlem Renaissance.

## Classical music in the Harlem Renaissance

The Harlem Renaissance, also known as the New Negro Movement, describes the centrality of Harlem to the establishment of African American culture within American modernity. This centrality accommodates Harlem's, New York's, and America's complex roles in what is increasingly understood as (in Claire Oberon Garcia's words) "a transnational phenomenon of black cultural and political affiliation",[58] a cosmopolitanism that resonates with the transnational and transatlantic white collaborations that organised *Four Saints*. Partly a product of the migration of large numbers of African Americans from the southern states, and spanning roughly the period 1918–37, the Harlem Renaissance was an extraordinarily productive period of literary, artistic, and intellectual labour, largely centring on the establishment and definition of African American identities and potentialities – what Alain Locke (editor of the definitive 1926 anthology *The New Negro: An Interpretation*) called "group expression and self-determination",[59] and what Jeffrey O.G. Ogbar has more recently defined as "black people exploring the challenges of being black in a virulently anti-black society".[60] Classical music occupied an ambivalent position in intellectual debate over these questions. David Levering Lewis, introducing his *Portable Harlem Renaissance Reader*, comments on the desire of intellectual leaders like W.E.B.

57 Henry Louis Gates, Jr, *Figures in Black: Words, Signs, and the "Racial" Self* (Oxford: Oxford University Press, 1987), p. 104.

58 Claire Oberon Garcia, "Jessie Redmon Fauset Reconsidered", in Jeffrey O.G. Ogbar (ed.), *The Harlem Renaissance Revisited: Politics, Arts, and Letters* (Baltimore: Johns Hopkins University Press, 2010), pp. 93–108; p. 93.

59 Alain Locke, "Harlem", in *Survey Graphic* (Harlem Number) (March 1925).

60 Jeffrey O.G. Ogbar, "Introduction" to *The Harlem Renaissance Revisited*, pp. 1–4; p. 1.

du Bois to "exclude the blues of Bessie Smith and the jazz of 'King' Oliver", and to favour the "*Lieder* of conservatory-trained Roland Hayes" as "appropriate forms to present to mainstream [i.e., white] America".[61] And Frank A. Salamone, writing on Duke Ellington, has recently asserted "the continuity between the Cotton Club and the Cathedral" in assessing the ambivalent perception in 1920s Harlem of jazz, with its "mixing of sacred and profane music".[62]

But (as Roland Hayes demonstrated) classical music practitioners existed, and could make a (sometimes precarious) living, in the Harlem Renaissance. Eileen Southern's extensive 1971 history, *The Music of Black Americans*, notes that "Because of the barriers of discrimination, performers generally found it very difficult to launch a career",[63] suggesting that the opportunity afforded to Harlem-based classical performers by a major mid-town event like *Four Saints* would have been well received by those people scouted out by Edward Perry, the "Negro talent scout" mentioned in Virgil Thomson's autobiography (and also, later in 1934, "the personal representative" of Edward Matthews).[64] Steven Watson nevertheless notes that "Thomson considered the renowned Marian Anderson but she was not interested"; he also auditioned Caterina Jarboro on 1 December 1933 "but quickly realized she was likely to be a temperamental diva".[65] Jarboro (1898–1986), from Wilmington, North Carolina, had studied in Paris and Milan, and in 1933 became the first African American to sing on stage in an opera in America when she performed in *Aida* with the Chicago Opera Company at the New York Hippodrome. Philadelphia-born Anderson (1897–1993), praised by Toscanini – "Yours is a voice one hears once in a hundred years" – and by Sibelius (who dedicated *Solitude* to her), gave her first recital at New York's Town Hall in 1924, and, in 1955, became the first black person to perform at New York's Metropolitan Opera House. She studied in London in 1925 and spent the next decade touring Europe, later being active in the 1960s civil

61 David Levering Lewis, "Introduction" to *The Portable Harlem Renaissance Reader* (New York: Penguin, 1994), p. xvi.
62 Frank A Salamone, "'It's All Sacred Music': Duke Ellington, from the Cotton Club to the Cathedral", in Ogbar (ed.), *The Harlem Renaissance Revisited*, pp. 31–41; pp. 39, 34.
63 Eileen Southern, *The Music of Black Americans: A History* (New York: W.W. Norton & Co., 1971), p. 414.
64 Thomson, *Virgil Thomson*, p. 238; Frances Moss Mann, "Roland Hayes Scores Again", *The New York Amsterdam News* (24 November 1934): 4.
65 Watson, *Prepare for Saints*, p. 248.

rights movements and working as a UN ambassador. Van Vechten photographed her in 1940.

If little is known of many of the performers of the early stagings of *Four Saints*, the contexts in which they worked can be glimpsed in some of the biographical and historical details – the places of birth, education, and records of stage appearances – outlining key figures in the music scenes of Harlem and New York, including composers, performers, concert-hall managers, and agents. The huge African American migration into Harlem from all over the USA (61 per cent of New York City's black population in 1910 had arrived there from elsewhere, principally from the Southern states) introduced an immense variety of musical skills, styles, accents of speech, and diverse cultural traditions, a climate ripe for complex cultural mixing and creativity.[66] Eileen Southern emphasises the resulting syncretic productivity of African American musical practices in the period after the First World War: "The composers used poems by black poets in their art songs; they exploited the rhythms of Negro dances and the harmonies and melodies of the blues as well as spirituals, and of the newer music called jazz in their composed concert music."[67]

Classical music was thus overtly hybridised by Harlem performers and composers, adjusted to accommodate and create specific forms, sounds, and rhythms which could also be found in jazz, blues, and rag, the dominant popular musical forms of the period. Locke's *The New Negro* includes essays on jazz and spirituals but not on classical music. Levering Lewis, in *When Harlem Was in Vogue*, cites as a crucial moment in the development of classical music in Harlem a concert at Harlem Town Hall by tenor Roland Hayes in December 1923, at which he sang both spirituals and lieder.[68] Hayes (1887–1977), born to ex-slaves in Curryville, Georgia, had performed before the King in England in 1920, an extraordinary elevation described by Marva Carter as a movement "From the plantation to the palace".[69] William Grant Still (1895–1978), the major African American composer of the period (known as "Dean of Afro-American composers"),

66 See "'Come Out From Among Them': Negro Migration and Settlement 1890–1914", in Gilbert Osofsky, *Harlem: The Making of a Ghetto – Negro New York 1890–1930* (New York: Harper and Row, 1968), pp. 17–34.

67 Southern, *The Music of Black Americans*, p. 413.

68 David Levering Lewis, *When Harlem Was in Vogue* (New York: Alfred A. Knopf, 1981), p. 163.

69 Marva Carter, "Roland Hayes: Expressor of the Soul in Song 1887–1977", *The Black Perspective in Music*, Vol. 5 (Autumn 1977): 188.

"maintained close personal and professional relationships with several prominent novelists, poets, and playwrights" in Harlem,[70] and worked on operas in collaboration with poets like Countee Cullen and (more successfully) Langston Hughes. In 1932, two years before *Four Saints*, Still recorded for WJZ radio. "Unfortunately," he wrote in 1933, "the folks at NBC are not broadminded. They don't want a Negro conductor. So I am now serving merely as an arranger."[71]

Another work by a major composer, William Levi Dawson's (1899–1990) syncretically titled *Negro Folk Symphony*, was first performed in 1934 (the year of *Four Saints*) by the Philadelphia Orchestra. Dawson had studied at Tuskegee and in Kansas and Chicago, and from 1931 to 1956 ran the Tuskegee Music faculty. Harry T. Burleigh (1866–1949), born in Erie, Pennsylvania, was the first black chorister at St George's Protestant Episcopal Church in New York. His repertoire, again emphasising the cross-cultural dynamism of the period, popularised a variety of forms ranging from folk songs and spirituals to minstrel and plantation melodies. Burleigh had worked as Anton Dvorak's copyist in 1893 at the National Conservatory of Music, and performed as baritone soloist in the 1904 Washington performance of Samuel Coleridge-Taylor's *Hiawatha's Wedding Feast*. Other classical musicians in Harlem included Marion Cumbo (1899–1900), a native of New York City and cellist in the Negro String Quartet, who recorded with blues singers Clara Smith (sister of Bessie) and Eva Taylor; he later performed with Marian Anderson, and played with the Eva Jessye Choir. Anne Wiggins Brown (1912–2009) auditioned before Gershwin in 1935, singing the Negro spiritual 'City Called Heaven', and performed as Bess, singing with Edward Matthews in *Porgy and Bess* at the Alvin Theatre in New York, 1935. In 1965 she directed a Norwegian production of the musical. Ruby Elzy (1908–43), born in Pontotoc, Mississippi, had graduated from New York's Juilliard School in 1934 and debuted on Broadway in 1930, subsequently starring with Paul Robeson in Dudley Murphy's film version of Eugene O'Neill's *The Emperor Jones* (1933). She also performed (as Serena) in *Porgy and Bess* in 1935 and 1942, and on tour. Van Vechten photographed her in 1935. Robert Nathaniel Dett

70 Gayle Murchison, "'Dean of Afro-American Composers' or 'Harlem Renaissance Man': The New Negro and the Musical Poetics of William Grant Still", in Catherine Parsons Smith (ed.), *William Grant Still: A Study in Contradictions* (Berkeley: University of California Press, 2000), p. 43.
71 William Grant Still, "Personal Notes", in Parsons Smith, *William Grant Still*, pp. 220–1.

(1882–1943), born in Drummondsville, Ontario, became, in 1908, the first person of African descent to receive a Bachelor in Music from the Oberlin Conservatory of Music. A student of his Hampton Institute Choir, Dorothy Maynor (1910–96), born in Norfolk, Virginia, founded the Harlem School of the Arts in the 1960s and was in 1975 the first African American named to the Metropolitan Opera board of directors.

While Grant Still and Levi Dawson were producing work in the contexts of American modernist interventions into classical music traditions, most of the people noted above would have worked in more conventional, traditionally oriented contexts, and many (like Marion Cumbo) would have been familiar with working across high and low cultural boundaries, performing with jazz and blues as well as classical musicians. Salamone's geographical and cultural continuity between the Cotton Club and the Cathedral was also generic – between popular and classical forms – and professional, with performers operating across and between musical modes and distinctions.

## The exhibition

*4 Saints in 3 Acts: A Snapshot of the American Avant-Garde* presents photographs (many never previously exhibited) and related ephemera in order to examine some of the ways portrait and documentary photography played their crucial roles in the representation and perception of the early performances of *Four Saints*, and to offer insights into the principal visual record of this extraordinary event – its provision of a unique arena in which those rich potentialities could find expression. In many cases these photographs are the only visual record of the musical and performance contributions of the African American singers and performers to the success of *Four Saints*, and add to our understanding of what Maurice O. Wallace and Shawn Michelle Smith describe as "the variety of effects photography had on racialised thinking" in the US.[72] They are also images that, entering the national imaginary through their circulation in widely read promotional material of the time, become, in Nicole R. Fleetwood's words, "part of the production and circulation of the racial narrative" of America, a country in which "visualizing

72 Maurice O. Wallace and Shawn Michelle Smith, 'Introduction', to *Pictures and Progress: Early Photography and the Making of African American Identity* (Durham, NC: Duke University Press, 2012), p. 9.

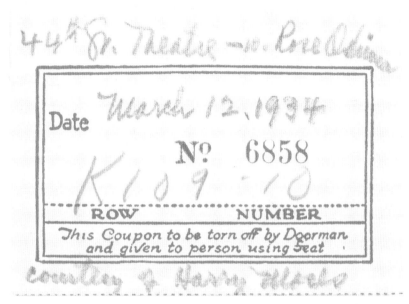

Figure 28  Original 44th St Theatre ticket for 12 March 1934 performance of *Four Saints in Three Acts*

is integral to narrating the nation".[73] Fleetwood's language recalls Homi Bhabha's important text *Nation and Narration* (1990) and its emphasis on the importance of understanding nation-formation as "a process of hybridity";[74] it also harks back to Gertrude Stein's *The Making of Americans*, a text connected in important ways to *Four Saints*. Creative hybridity, and its syncretic effects, characterise the processes through which *Four Saints* was produced.

The essays collected here address different aspects of the complex syncretic totality that was *Four Saints*. Patricia Allmer considers photography's relations to and roles within the opera and its strange temporailty; Lisa Barg explores the musical forms of the opera; Christopher Breward analyses its place in fashion history; Lucy Weir discusses Ashton's contributions to English choreographical traditions; John Sears examines Stein's writing; and Steven Watson recounts meeting key figures involved in the original production.

73 Nicole R. Fleetwood, *On Racial Icons: Blackness and the Public Imagination* (New Brunswick: Rutgers University Press, 2015), p. 3.
74 Homi K. Bhabha, "Introduction" to *Nation and Narration* (London: Routledge, 1990), p. 4.

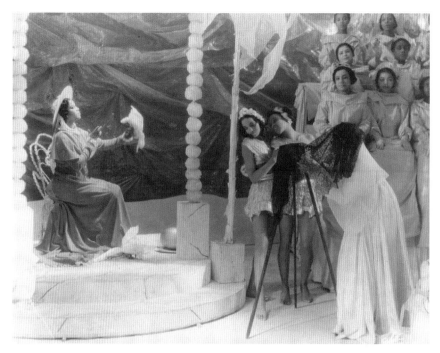

Figure 29  White Studio, scene from the theatrical production *Four Saints in Three Acts* at the Wadsworth Atheneum, Hartford, Connecticut, 1934

The final chapter presents a Gallery of rarely seen and, in some cases, previously unreproduced portraits by Lee Miller and Carl Van Vechten of some of the African American cast and their choir master, together with the cast lists printed in the programmes accompanying the various 1934 performances. Daniel Albright argues that *Four Saints* was "an opera that tries to be a picture – an opera in which the text defies discursivity and the music defies temporal progression", a work in which "the temporal media" might be violently reconfigured ("wrenched so strongly", writes Albright) to "provide the delights formerly reserved for the spatial media".[75] The essays in this collection, and the photographs and illustrative material presented in *4 Saints in 3 Acts: A Snapshot of the American Avant-Garde*, explore some of the ways photography recorded and affected this process of "wrenching" during a unique moment in American cultural history.

75  Daniel Albright, "An Opera with No Acts: *Four Saints in Three Acts*", *The Southern Review*, Vol. 33 No. 3 (Summer 1997): 574–605; 574.

1

# Moving pictures: photography and time in *Four Saints in Three Acts*

*Patricia Allmer*

Photography's relation to *Four Saints in Three Acts* is literally eccentric. Deriving from the Greek word *ekkentros* from *ek*, 'out of' and *kentron*, 'centre', the eccentric defines photography's double function, both peripheral and integral to the opera. At the most basic level photography offers a documentation of *Four Saints* – in many respects, the only existing documentation of performers, artists, and singers whose careers have been omitted from the histories of their respective disciplines; and yet, as this essay will argue, it simultaneously occupies an integral role as an intrinsic part of the opera when understood as a complex and multi-media form of representation. Photography furthermore emphasises in this eccentricity, through its characteristically modernist questioning of the processes of linguistic and pictorial representation, a key aspect of the avant-garde dimensions of *Four Saints*. At the heart of photography's eccentric relation to *Four Saints* resides the question of time, and of the strange, dislocated, circular avant-garde temporalities that the opera sets in motion: as one recent critic notes, "How and when can an opera end – once and for all – when it is so thoroughly preoccupied with beginning again and again?"[1] The various temporalities

---

1 Joseph Cermatori, "Unsettling Gertrude Stein: on the Citability of Baroque Gesture in *Four Saints in Three Acts*", *Modern Drama*, Vol. 58 No. 3 (Fall 2015): 347–69: 363.

of movement and stasis, and of repetition and difference, organise the various functions of the photograph in relation to the opera and the different temporalities of its musical, textual, and performance dimensions. Photography's relations in one direction to the modern forms of time and movement introduced by cinematic imagery, and in the other to the traditional temporalities and movements of "live" stage performance, embody the complexities of *Four Saints* as a work scrutinising both temporality and movement through the mingling of historical and modern experiences and figures, and the melding of processual and static forms of performance.

A crucial aspect of this scrutiny can be seen in effects like the blur, an effect of movement and an element of image-form arguably specific to the mechanical image, a product of the tension between the (living) movement of the object and the (mechanical) stasis of the medium, and indicative of the time-distribution of the trace within the field of the image. Photographic and cinematic blurring effects offer implications that ramify outwards into other elements of the opera's form, including the "blur-effect" of Stein's linguistic repetition and the "blurring" of libretto and stage directions in Virgil Thomson's setting of Stein's text. The text of *Four Saints* invites formal comparison with modernist precursors such as Marcel Duchamp's engagements with photography in works like *Nude Descending a Staircase No. 2* (1912), or the early chronophotographic experiments with photography, motion, and time of Étienne-Jules Marey and Eadweard Muybridge. These acknowledgements of tradition affirm the significance of modernist seriality to questions of 'newness' within repetition, questions that impinge also on the specific temporalities of newness and tradition invoked by the role of fashion in *Four Saints* (discussed in Christopher Breward's essay). Sarah Bay-Cheng argues that "Saint Theresa, an icon from the past, consequently becomes an avant-garde construction – a picture in sequence, with each stage of the development from girl to nun simultaneously represented".[2] The essentially cubist conception of aesthetic simultaneity intersects with the seriality of the cinematic image, the flicker of sequentiality producing the illusion of movement, which Stein insisted on relating in her theoretical writings to the still image of the photograph – itself a form of serial reproduction. Stein noted in her 1934 lecture *Plays*,

---

2 Sarah Bay-Cheng, "Famous Unknowns: The Drama of Djuna Barnes and Gertrude Stein", in David Krasner (ed.), *A Companion to Twentieth-Century American Drama* (Malden, MA, and Oxford: Blackwell Publishing, 2005), p. 137.

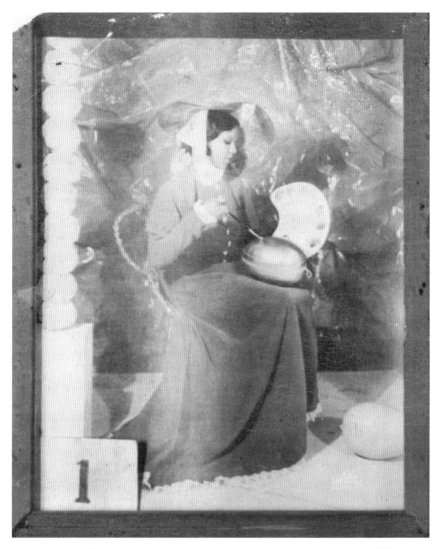

Figure 30 White Studio, scene from the stage production *Four Saints in Three Acts*, 1934

"there is yet the trouble with the cinema that it is after all a pho-
tograph, and a photograph continues to be a photograph and yet
can it become something else?"[3] This Steinian comprehension of
film, paraphrased by Beth Hutchinson as "simply the procession of

3 Gertrude Stein, "Plays" (1934), in Robert Knopf and Julia Listengarten (eds),
  *Theater of the Avant-Garde, 1890–1950: A Critical Anthology* (New Haven, CT, and
  London: Yale University Press, 2015), pp. 425–40; p. 436.

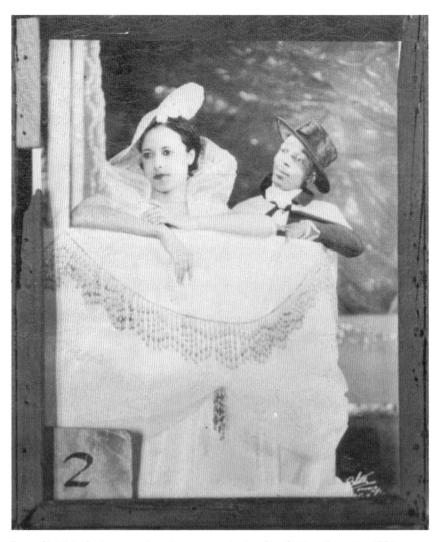

Figure 31 White Studio, scene from the stage production *Four Saints in Three Acts*, 1934

a series of photographs",[4] returns in the seriality of the *Four Saints* portraits by Miller and Van Vechten, and the performance shots by White Studio. It suggests some of the ways *Four Saints* might be understood as playing with the possibilities of transferring photographic and cinematic effects into other media – specifically effects

4 Sarah Bay-Cheng, *MAMA DADA: Gertrude Stein's Avant-Garde Theatre* (London: Routledge, 2005), p. 43.

dependent on the different but closely linked relations of photography and cinema to movement.

Further related, but distinct, visual effects might include the processes of erasure and concealment (extreme forms of blurring and smudging) that intervene in the representations of the African American performers, and which inexorably accompany and are intrinsic to the photographs, illustrating the medium's complicity in the complex racial politics of *Four Saints* and its Harlem-mid-town hybridities, as well as in photography's wider complicities in the controls and constructions characteristic of particular kinds of racialised representation. Lee Miller notoriously (but characteristically for the time) used red filters to lighten the performers' skin in her portraits of them, and applied carefully structured portrait lighting techniques she learnt as a *Vogue* photographer. Carl Van Vechten's portraits of the same performers need furthermore to be understood in relation to his wider project of producing photography that was (James Smalls argues) "fetishistically critical to [his] psychological and social definition", "an artistic expression of cultural and racial documentation, [which] employed the medium as a means of popular myth-making about himself in relation to African Americans".[5]

Photography's eccentric relation to *Four Saints* is initially evident in elements of the reception and perception of the opera. Photographs offer vital material evidence of the contributions of cast members to the performances, ostensibly subverting the "invisibility" that tended to accrue to African Americans working in conventionally "white" cultural spaces like opera. Performers' names were often omitted from reviews in leading newspapers at the time such as the *New York Times*, which focused instead on anchoring the opera and its successes in the contributions of the (white, with the singular exception of Eva Jessye) crew. *The Stage* introduces *Four Saints* as an opera "written by Gertrude Stein (*Tender Buttons*) and composed by Virgil Thomson in her image", thus emphasising the centrality of the image to its version of the opera.[6] The reviewer in *Town & Country* mentions only Edward Matthews by name. Captions accompanying photographs of the cast performing repeatedly cite other members of the crew by

5 James Smalls, "Public Face, Private Thoughts: Fetish, Interracialism, and the Homoerotic in Carl Van Vechten's Photographs', in Deborah Bright (ed.), *The Passionate Camera: Photography and Bodies of Desire* (London and New York: Routledge, 1998), pp. 78–102; p. 79.
6 Review of "*4 Saints in 3 Acts*", *The Stage* (April 1934): 22.

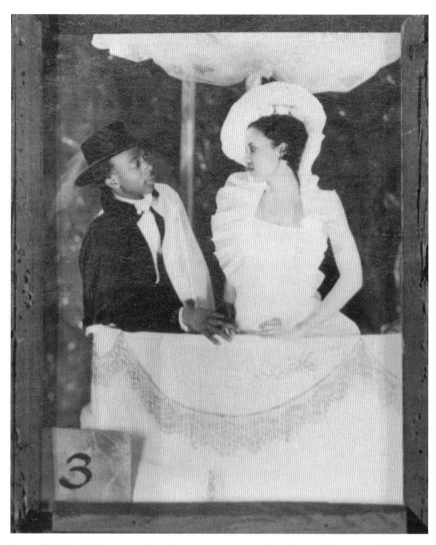

Figure 32 White Studio, scene from the stage production *Four Saints in Three Acts*, 1934

name, but tend to identify characters rather than performers: "The Commère, Saint Chavez and Saint Settlement are now at the Forty-fourth Street Theatre. Settings 'by' the painter Florine Stettheimer."[7] Subsequent academic and popular accounts of *Four Saints* reinforce photography's eccentric relation to the opera, while theoretical

7 Samuel Chotzinoff, "Four New Operas in One Week", *Town & Country* (1 March 1934): 20–1; 21.

surveys of photography in the 1930s largely ignore it. Joseph B. Entin's *Sensational Modernism*, for example, makes no mention of *Four Saints* during its survey of "Experimental Fiction and Photography in Thirties America". Publications reproduce little of the fairly extensive existing photographic documentation; when photographs are used, they are largely treated simply as documentary evidence, with the names of the photographers frequently omitted. Joseph Cermatori's recent analysis of the baroque elements of *Four Saints* reproduces two White Studio photographs (including that of St Theresa being photographed, discussed below) but doesn't credit the studio.[8] The photographs *per se* are rarely discussed or subject to any extended critical scrutiny. In these ways, the marginality of photography to *Four Saints* and of the photography of *Four Saints* to critical histories is officially sustained.

However, photography is, of course, central to *Four Saints*. Numerous photographs across a variety of genres provide an extensive collage of variously motivated images, affording glimpses of the materiality of the 1934 performances, and simultaneously offering insights into many of the contemporary functions of photography itself – intellectual, artistic, political, and ethical, as well as documentary – and demonstrating the various ways in which different temporalities of modernity intersect within *Four Saints*. A non-exhaustive list of significant photographic elements would begin with the history of the opera's genesis and development, recorded in the ca. 1929 photographs by Thérèse Bonney of Stein and Thomson working on *Four Saints* in Stein's Paris house at 7, Rue de Fleurus. Bonney, a close friend of Stein, is perhaps best known for her work as a Second World War photographic correspondent. More immediately connected to the opera is the commissioning of Lee Miller (another Second World War photographic correspondent) by stage director John Houseman (who was at the time Miller's lover) to photograph the cast and crew in late 1933 for the opera programme and press material, inserting photographic versions of the opera into commercial and media temporalities. Carl Van Vechten's photographs of the cast in March and April 1934 were likewise used in the press, but also worked up as postcards to promote the event (one of which he sent to Gertrude Stein in Paris, connecting *Four Saints* to the global temporality of postal and communications systems). George Platt Lynes photographed homoerotic stagings of naked cast members with a conspicuously suited Frederick Ashton, producing highly eroticised

8 Cermatori, "Unsettling Gertrude Stein".

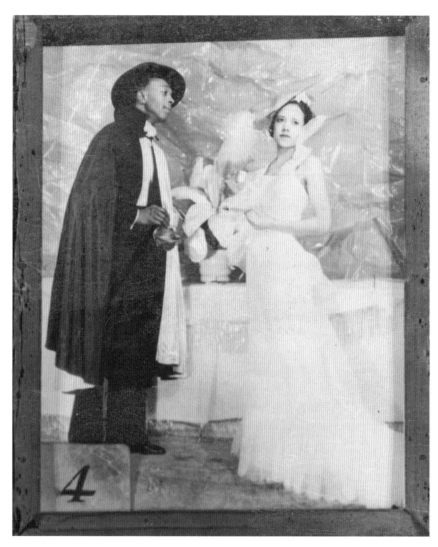

Figure 33 White Studio, scene from the stage production *Four Saints in Three Acts*, 1934

images of black and white bodies existing in semiotically mythical temporalities drawing on racial histories. As Thomas Waugh has pointed out (and as Lisa Barg discusses in her essay), these pictures, in which "the three teenage black dancers pose nude, reclining alongside a clothed and upright white choreographer who touches them paternally [...] reflect uncomfortable political realities".[9]

9 Thomas Waugh, "Posing and Performance: Glamour and Desire in Homoerotic Art Photography, 1920–1945", in Bright (ed.), *The Passionate Camera*, pp. 58–77; p. 72.

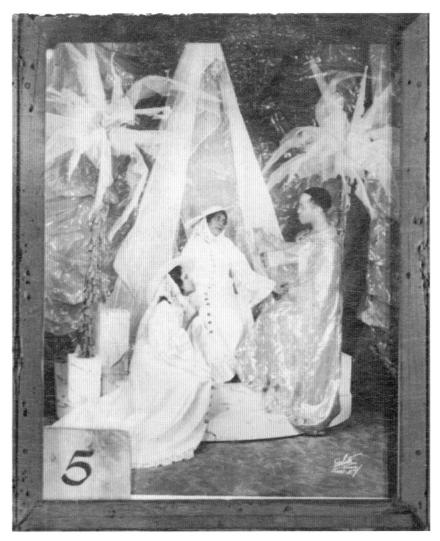

Figure 34  White Studio, scene from the stage production *Four Saints in Three Acts*, 1934

Photographic documentation of works used in the performance includes pictures of Florine Stettheimer's set design mock-ups for *Four Saints*, depicted by the respected New York photography firm Peter A. Juley & Son. Stettheimer painstakingly assembled many scenes in a box which functioned as a model for the theatre stage. These constructions included maquettes, costumes, and props collaged of different textiles, materials, beads, and wires, producing works reminiscent of Alexander Calder's *Circus* figurines from

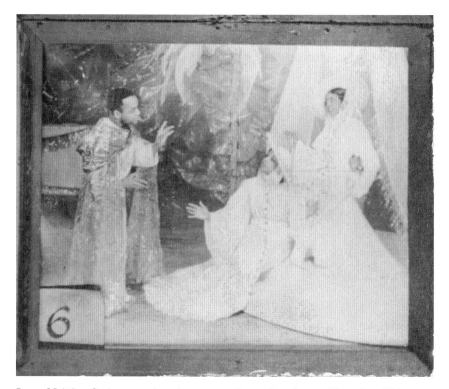

Figure 35 White Studio, scene from the stage production *Four Saints in Three Acts*, 1934

1926–31. The box is a simple model connoting the theatre stage on which scenes are enacted, and the Juley & Son photographs, when compared with later photographs of the performances, make clear how Stettheimer's real stage, draped in lace and cellophane, was itself modelled closely on the oddly co-ordinated appearance of this box, giving the actual staging the appearance of a scaled-up puppet-set or a gigantic box of trinkets or presents, the cellophane of the full-size stage set and costumes mimicking packaging, as if a box were packaged and its contents wrapped. The glistening cellophane, reflecting lights in a multitude of directions, added further mobile lustre to the spectacle recorded in these images.

Press photography established the opera as a public phenomenon, inserting it into the mediated temporalities of public modernity. Press photographs of the performances include Harold Swahn's images offering detached views of actual performance scenes from March 1934, and the images made by photographers of the White Studio, Broadway's foremost photographic recorder of stage pro-

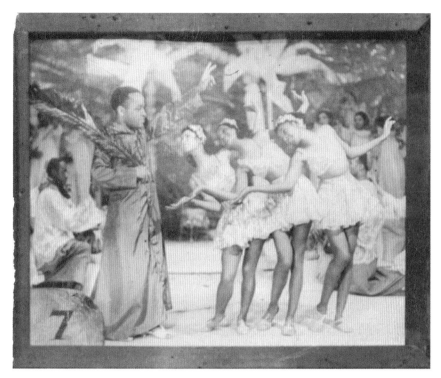

Figure 36  White Studio, scene from the stage production *Four Saints in Three Acts*, 1934

ductions from 1905 until 1939. White Studio specialised in frontal panoramas of theatrical performances taken during dress rehearsals and occasionally during the performances, necessitating the momentary freezing of the rehearsal for the photograph to be taken. Photography (as indicated in the photographer's cry of "Hold it there!") effected in these moments a kind of interruption to the sequential progression of the opera, a punctuation of its flow as performance. Press, portraiture, and documentary photographs of *Four Saints* thus combine to construct a complex, multifaceted and temporally various event, and produce a body of work subjecting the opera to a variety of modes of perception and analysis, blurring the distinctions between the "representational strategies" of scrutiny, sentiment, and sensation that (Joseph B. Entin argues) organise American photography in the 1930s.[10]

10 Joseph B. Entin, *Sensational Modernism: Experimental Fiction and Photography in Thirties America* (Chapel Hill: University of North Carolina Press, 2007), pp. 35–6.

The White Studio photographs of the *Four Saints* rehearsals show the shimmering stage and costumes, and record the opulence and luminous brilliance of the performers and set. One White Studio photograph records a key moment in *Four Saints* in which photography is suddenly absolutely central to the work itself, an action embedded within its acts. A short, two-minute scene in Act I, Tableau II is titled "St Theresa II with dove, being photographed by St Settlement". Thomson worked up Stein's libretto for this brief tableau as follows:

> Altos (Chorus I): Saint Theresa could be photographed having been dressed like a lady and then they taking out her head changed it to a nun and a nun a saint and a saint so.
> Commère: Saint Theresa seated and not surrounded might be very well inclined to be settled.
> St Theresa I: Made to be coming here. How many saints can sitaround.[11]

The scenario exploits two significant elements dependent on photography: the potential for transformative and collagistic photographic editing ("taking out her head and changed it to a nun"), and the tension in the performance between stasis and movement, between "being seated" "sitting around", and "inclining" and "coming here", suggestive of the photograph's momentary fixing of movement. The future conditional verbs "could be" and "might be", and the past perfect "having been", combine to effect the fluctuating linguistic temporality characteristic of Stein's writing which is, here, situated within and around the process of taking a photographic portrait, formally akin to those made by Miller and Van Vechten. Photography's own strange temporality, its Barthesian "this-has-been", is thus echoed in the libretto's language; the two distinct temporalities of text and photograph mirror each other, indicating a reciprocity that informs the whole of *Four Saints*. A further emphasis on this strange temporality is made possible by the text's insistent repetitions, its formal recursiveness, as described by Sarah Bay-Cheng:

> Keeping track of the number of acts is nearly impossible. As [Stein] writes in Scene X (one of many such titled scenes), "Four

11 Virgil Thomson, *Four Saints in Three Acts, An Opera: Complete Vocal Score* (New York: G. Schirmer, Inc, 1948), p. 35. See Gertrude Stein, FOUR SAINTS IN THREE ACTS. AN OPERA TO BE SUNG, Typescript carbon (1934), p. 12. Gertrude Stein and Alice B. Toklas Collection, YCAL MSS 77, Box 1, folder 12, Series I. Writings, Four Saints in Three Acts.

Acts could be four acts could be when when four acts could be ten". Scenes repeat themselves (there are nine "Scene V's") and ambiguous stage directions further complicate Stein's structure: "Repeat First Act" [16] and "Enact the end of an act" [17].[12]

This interminable play of tenses and structural repetitions also emphasises another crucial element of *Four Saints*: its concern with the image as a form of reproduction embedded simultaneously in the double temporal effects of movement and of stasis, a concern that preoccupied much of Gertrude Stein's theoretical writing. If linguistic tenses introduce the element of temporality into the written text, Stein sought also to engage in her work with the new, modernist temporalities suggested by the reproductive force of the moving image made possible by cinema alongside that of the still image of photography. *Four Saints* becomes within this framework of concerns a multi-media text presenting various temporalities, a series of static tableaux caught up in complex systems of dynamic movement signified from the very beginning in the opening, highly energised waltz-progressions of Thomson's score. Its lack of overt narrative (its repetitions and obscurities of reference) masks a deeper concern with the very structures of temporal apprehension in musical, textual, and visual media. Photography's position within this network of relations becomes increasingly complex; an element of the multi-media work, it is also something performed in the action as well as being the medium in which the performances and the cast and crew have been documented. Photography simultaneously enacts *Four Saints* as it is enacted within *Four Saints*, becoming part of the opera's time even as it imposes its own temporalities and interruptions on the opera's performance and representation.

The performance of taking a photograph, taking up a short period within the opera, adds to the photographic image the element of dynamism, of temporality associated with enacting, but also embeds within this dynamism the moment of stasis – the interruption – required for the taking of the photographic image. Comments by Virgil Thomson and Frederick Ashton indicate that the performances of *Four Saints* were regulated by notions of control, both of the performers and of the visual experience of the audience. The opera singers took on new challenges beyond the difficulties of memorising Stein's text, with its modulating variations within extensive repetitions and its seemingly nonsensical lines contradicting conventional

12 Sarah Bay-Cheng, "Famous Unknowns", pp. 127–41; p. 137.

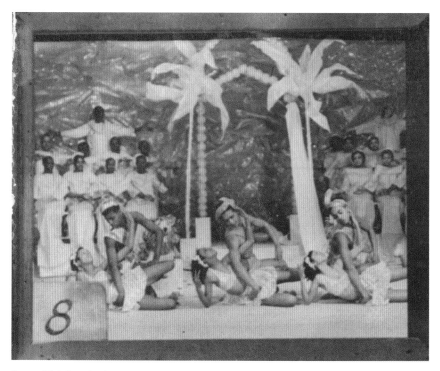

Figure 37  White Studio, scene from the stage production *Four Saints in Three Acts*, 1934

notions of sequential learning-by-rote, and the problems of how to project an operatic singing voice while involved in dance movements, in contrast with the Wagnerian conception of the immobile opera singer projecting the voice from a static position. While the opera's multi-mediality invites comparison with the Wagnerian *Gesamtkunstwerk*, it is precisely this Wagnerian conception of opera with which Virgil Thomson tried to break; he referred specifically to the "Wagner opera" where singers "stand around and sing in appropriate costumes; that's about all they do".[13] Discussing Frederick Ashton's contribution, Thomson elaborates that

> I needed a professional choreographer; [...] you mustn't let the singers just wander around or improvise their movements [...] I still think that opera sounds better when it is arranged choreographically, than it does when the singers are allowed to do their own acting [...] music is a completely regulated entertainment

13  Virgil Thomson in John Gruen, Interview with Virgil Thomson, 1 May 1975, The New York Public Library, Performing Arts Research Collections – Dance, *MGZTL 4–344, sound discs.

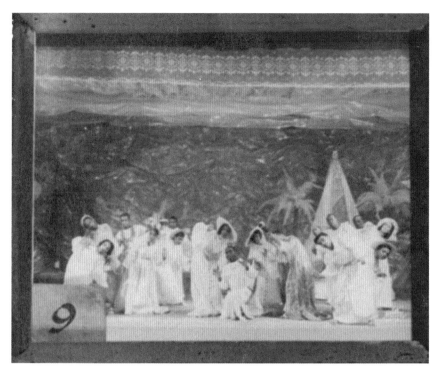

Figure 38  White Studio, scene from the stage production *Four Saints in Three Acts*, 1934

> [...] there is no proper place for singers to improvise. The completely regulated stage as we see it in ballet, the control of a ballet is what the opera needs.[14]

Directorial control of mobile performers, and of stage and performance as regulated elements of a potentially disruptively mobile space, is thus central to Thomson's intentions in organising *Four Saints*.

The significance of movement is also clear from Ashton's comments on choreographing the procession scene in *Four Saints*. The performers

> had to do a procession across the stage; I did that, that they were moving – impression of a procession moving – they were swaying; and then step forward: impressed people at the time.[15]

14 Ibid.
15 Frederick Ashton, David Vaughan interview with Frederick Ashton, 9 August 1973, The New York Public Library, Performing Arts Research Collections – Dance, *MGZTL 4–517, sound disc, Disc 5.

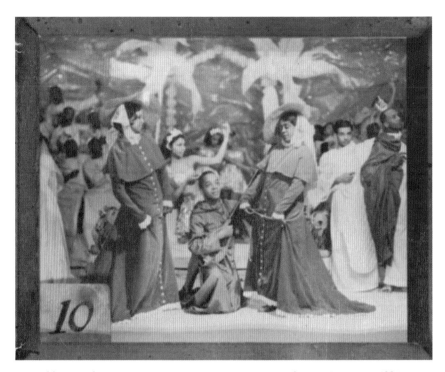

Figure 39  White Studio, scene from the stage production *Four Saints in Three Acts*, 1934

This invisible, nearly floating movement of dance gestures forward to Thomson's 1936 direction of a 1920 piece by Eric Satie, *Socrate*, again performed at the Wadsworth Atheneum, for which Thomson invited Alexander Calder to design a set which deployed motion barely perceptible to the audience. Thomson referred to Calder's set as a "balletic instrument" which moved "on cue and follows the story": it moves "very little", "very slow motion by the scenery, because it's primarily a musical work – scenery doesn't take over the show". This slow motion is "very expressive, and quite moving".[16] Thomson's awareness of the double meaning of movement as dynamism and emotion is thus explicit; control of theatrical dynamism is also, for Thomson, regulation of emotion.

The movements introduced by Thomson into both these pieces seem to mimic, or at least derive from, cinematic motion, in which a sequence of static images creates the illusion of movement, not its actuality. In *Four Saints* this balletic-cinematic element of motion is enhanced further still, by movement introduced through the

16 Ibid.

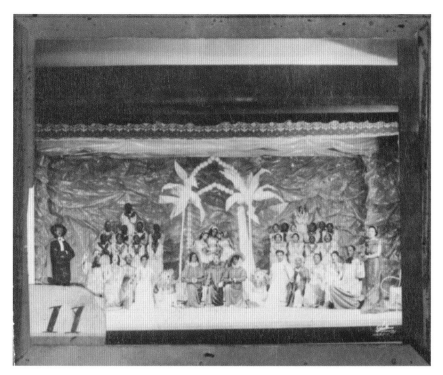

Figure 40  White Studio, scene from the stage production *Four Saints in Three Acts*, 1934

flickerings and glistenings of Stettheimer's cellophane set designs and costumes, captured in the White Studio photographs. The folds and pleats of these materials invite a kind of haptic vision which, according to Laura Marks, is "more inclined to move than to focus, more inclined to graze than to gaze".[17] Such a vision is not allowed to rest, but is drawn into endless mobility, forcing the audience to squint, constantly to focus and refocus their eyes, reminiscent of the ways Stein's words work in relation to listening and relistening, reading and rereading. The colour effects of Stettheimer's cellophane stage design enhanced this impression. Thomson described the cellophane used in the original set for the Hartford and Broadway productions, but subsequently dropped owing to New York City's fire regulations, as "sky blue […] a curtain made out of cellophane sewn onto a net and tufted; there were lights in front and back. You could make it look like an iceberg, or a river".[18]

17  Laura U. Marks, *The Skin of the Film: Intercultural Cinema, Embodiment, and the Senses* (Durham, NC: Duke University Press, 2000), p. 162.
18  Ibid.

The moment of St Theresa being photographed pierces this flow of movements and motions of and towards the cinematic in *Four Saints*. Being photographed offers the static moment, where both live performance and the photograph punctuate the flow of the motion picture. If the White Studio photograph demands that the performers stand still to be photographed, they also stand still within the opera's action while the act of taking the photograph is performed – St Theresa strikes a pose for her being photographed while being photographed, just like the many poses of the cast portraits by Van Vechten and Miller. If the moment of the production of a photographic image within the play demands stasis, so too do the White Studio photographs, which were taken during rehearsals, with the cast standing still for the long indoor exposure, to avoid blurring. This momentary standstill creates a strange *tableau vivant* of the actual performance, which was itself (as many commentators have noted) structured by precisely the *tableau-vivant* format, a style emerging from a tradition of French forebears (including Jean-Baptiste Lully, Rameau, Gluck, Meyerbeer, Berlioz, Debussy, and Poulenc)[19] which (Jack Beeson writes) set to music "texts of quality [and maintained] exacting standards of declamation, a tableau-like sequence of scenes, and a penchant for ballet and choreographed movement in general".[20] Cermatori notes that Ashton's choreography "arranged the performers' bodies into a series of *tableaux vivants*, alternating between continuity of movement and the sort of momentary frozenness that allows a gesture to settle'.[21] Again, avant-garde temporality emerges in the relation between movement and its arresting or punctuation.

In its initial performances the opera was intimately bound to its location in the Wadsworth Atheneum. *Four Saints* formed the centrepiece of the 1934 celebration of the inauguration of the museum's Avery Memorial wing, an opening marked by the first American retrospective of Picasso, including the newly acquired collection of his original sketches for the Diaghilev ballet. Parallel to this, the museum also displayed another recently acquired collection of Italian baroque paintings for the inaugural ceremony. The

---

19 Virgil Thomson and Gertrude Stein, *Four Saints in Three Acts: Full Score*, ed. H. Wiley Hitchcock and Charles Fussell (Middleton: A-R Editions, 2008),p. xxxiv.
20 Jack Beeson, "Virgil Thomson's Aeneid", *Parnassus*, Vol. 5 No. 2 (Spring–Summer 1977): 478.
21 Cermatori, "Unsettling Gertrude Stein", 352.

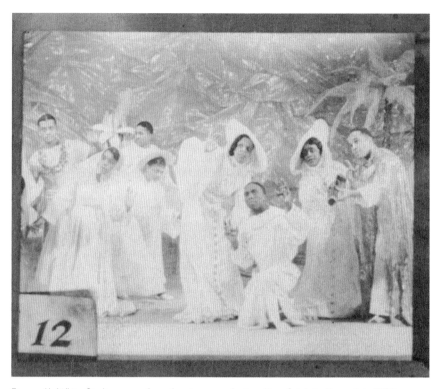

Figure 41 White Studio, scene from the stage production *Four Saints in Three Acts*, 1934

concurrent exhibitions were, as Lisa Barg argues, "well tailored to the opera's mise-en-scène. [...] both the primitivist plasticity of the Picassos and the static opulence of the baroque paintings found a host of performative analogues on the museum's stage".[22] These aspects can be traced in the photographic work related to *Four Saints* by Bonney, Miller, and Van Vechten.

Bonney's portrait depicts Thomson and Stein working on the score and libretto against a blurred background, patterned by Stein's artworks, including Picassos, while the flowery patterns, lace and folded textures of Stein's clothing already connote the florid baroqueness of the opera's textile surfaces. Elements of Bonney's photograph are echoed in those by Miller and Van Vechten. Patterns and rhythms inviting Marks's "grazing gaze" are established in the seriality of their photographs, as well as in the contrast between foreground

22 Lisa Barg, "Black Voices/White Sounds: Race and Representation in Virgil Thomson's *Four Saints in Three Acts*", *American Music*, Vol. 18 (Summer 2000): 121–61; 122.

and background in Miller's photographs, and the repeated erasure of the distinction between the two in those by Van Vechten, in which the sitter is often partly overlaid and even obscured by elements of the scene, which in turn merge with or repeat aspects of the background patterns, effecting a kind of photographic dynamism as ground and figure, foreground and background become confused.

In Miller's portraits, the cast members enact different saintly poses while the background, consisting of an undisguised, sometimes wonkily hanging angular sheet of paper against a dark background, recalls the incompleteness of collage, gesturing towards Picasso's work. The flat, uniformly coloured rectangular background areas

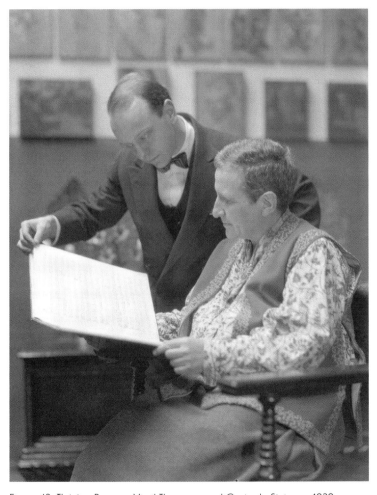

Figure 42  Thérèse Bonney, Virgil Thompson and Gertrude Stein, ca. 1929

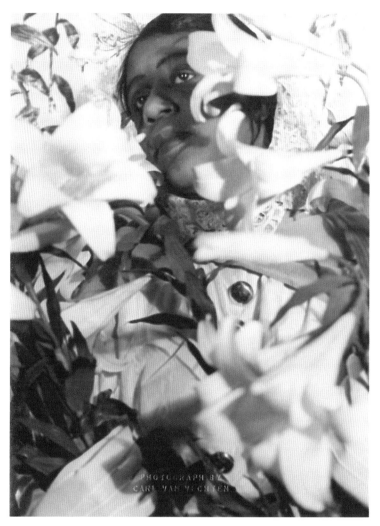

Figure 43 Carl Van Vechten, Beatrice Robinson-Wayne as St Theresa in *Four Saints in Three Acts*, 9 March 1934

evoke cubist and even suprematist aesthetics, effecting a static ground upon which the portrayed sitter appears in counterpoint, their implicit mobility emphasised by the mobility implied in the conspicuous flow of the baroque folds of the costume materials, evoking what Harris calls the "sculptural, baroque quality of drapery so essential to [Stettheimer's] conception".[23] The tension between

23 David Harris, "The Original *Four Saints in Three Acts*", *The Drama Review* Historical Performance Issue, Vol. 26 No. 1 (Spring 1982): 101–30; 107.

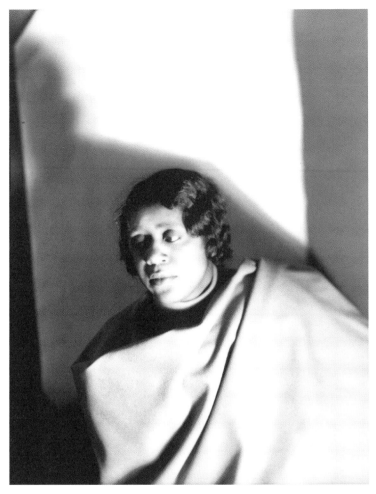

Figure 44 Lee Miller, Beatrice Robinson-Wayne, Soprano, *Four Saints in Three Acts*, New York Studio, New York, ca. 1933

movement and stasis that structures the entire opera, so crucial to its engagement with avant-garde temporalities, is thus achieved and sustained in Miller's portraits by the counterpoint of modernist and baroque image-elements.[24]

The moment of St Theresa being photographed, and its recording by White Studio, is thus a moment of representational doubling

24 I discuss the effects of baroque folds in Miller's *Four Saints* photographs in chapter 3 of *Lee Miller: Photography, Surrealism, and Beyond* (Manchester: Manchester University Press, 2016), pp. 59–88.

Figure 45  White Studio, keysheet for stage production, *Four Saints in Three Acts*, 1934

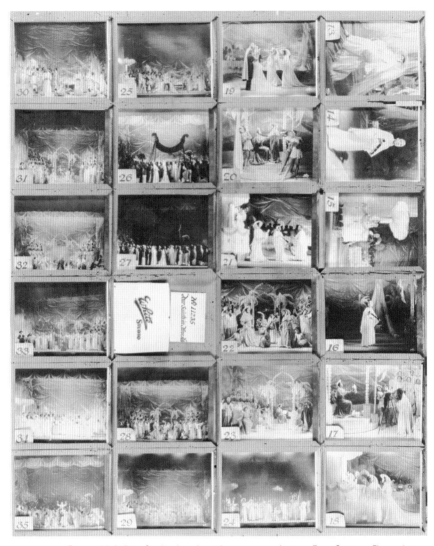

Figure 46 White Studio, keysheet for stage production *Four Saints in Three Acts*, 1934

which collapses photography's peripheral relation (recording, documenting) into its integral one (performing, enacting) within *Four Saints*. It introduces into the opera the time of photography as an interruption. In this moment photography is no longer detached from the work but becomes a crucial dimension of *Four Saints*, part of both its action and its representation, and a constituent element of the opera's concern with baroque, "cyclical and

theatrical"[25] temporalities. Photography adds another vital element to the wide range of media and aesthetic disciplines, including poetry, theatre, opera, musical, costume design, and painting, involved in *Four Saints*. Notwithstanding Virgil Thomson's overt refusal of the Wagnerian connotations of the term, Steven Watson is surely right to describe the opera "America's first grand scale *Gesamtkunstwerk*".[26]

25  Cermatori, "Unsettling Stein", 353.
26  Steven Watson, *Prepare for Saints: Gertrude Stein, Virgil Thomson, and the Mainstreaming of American Modernism* (New York and Toronto: Random House, 1998), p. 76.

# 2

# Modernism in tableaux: race and desire in *Four Saints in Three Acts*

*Lisa Barg*

Not long after its celebrated six-week run on Broadway, in February of 1934, Virgil Thomson's opera *Four Saints in Three Acts* on a libretto by Gertrude Stein was hailed a landmark of American musical modernism.[1] This was no small claim for a work conceived and composed in Paris, mixing dadaistic aesthetics and musical Americana, all animated by the spectacle of a sizeable cast of African American singers and dancers performing as sixteenth-century Spanish saints against a 1,400 sq ft cyclorama backdrop made entirely of cellophane. In a letter to Gertrude Stein written the day following the opera's star-studded Hartford premiere – some two weeks before its Broadway opening – Carl Van Vechten enthused:

> I haven't seen a crowd more excited since *Sacre du Printemps*. The difference was that they were pleasurable excited [*sic*]. The Negroes are divine, like El Grecos, more Spanish, more Saints, more opera singers in their dignity and simplicity and extraordinary plastic line than any white singers could ever be. [...] Frederick Ashton's rhythmic staging was inspired and so were Florine Stettheimer's costumes and sets. Imagine a crinkled sky-blue cellophane

---

1 The production ran for four weeks at the 44th St Theatre, moving to the larger and more prestigious Mercury Theatre for the final two weeks.

background, set in white lace borders, like a valentine against which were placed the rich and royal costumes of the saints in red velvets, etc. and the dark Spanish skins.[2]

With its potent mix of race, desire and art, Van Vechten's description furnishes a resonant snapshot of the cultural and affective histories informing the original production of the opera as well as the capacity of such histories to elicit "pleasurable" excitement from "a crowd". As I've argued elsewhere (Lisa Barg, 'Black Voices/ White Sounds: Race and Representation in Virgil Thomson's *Four Saints in Three Acts*', *American Music*, Vol. 18 (Summer 2000): 121–61), the participation of the African American performers informed the opera's history at almost every level – from its compositional and aesthetic foundation, choreography and staging to its unprecedented "crossover" appeal and the sensational media coverage it generated. Indeed, the images from the original production – Van Vechten's and Lee Miller's cast photographs among them – powerfully document the critical role of race and sexuality played in shaping the opera's production and reception. With equally strong links to Stein's Parisian salon, the New York art world, and the Harlem cultural elite, Van Vechten in particular was in the perfect position to promote *Four Saints*, and he became one of the opera's most devoted and enthusiastic supporters. In addition to a series of photographs of some of the principal cast – Beatrice Robinson Wayne (St Theresa), Edward Matthews (St Ignatius), and Altonell Hines (Commère) – he wrote an introduction to the published libretto (distributed along with programmes during both Hartford and Broadway runs), and penned two influential reviews. This essay seeks to contextualise this material as well as other extant iconography from the original production in relation to the opera's histories of race, sexuality, and modernism.

From its genesis in Paris as an essentially plotless 1927 score and libretto to its realisation in the 1934 performance, the transatlantic journey of *Four Saints* charted a long and complicated route. The story of the production itself presents a vivid microcosm of the extensive cosmopolitan network and collaborative ethos that fostered a variety of modernisms, reaching across borders of race, gender, nation and through drawing rooms, salons, and cabarets. Critical reception of the work as a distinctively American modern

---

2 *The Letters of Gertrude Stein and Carl Van Vechten 1913–1946* (ed. Edward Burns), Volume 1 (New York: Columbia University Press, 2013), p. 295.

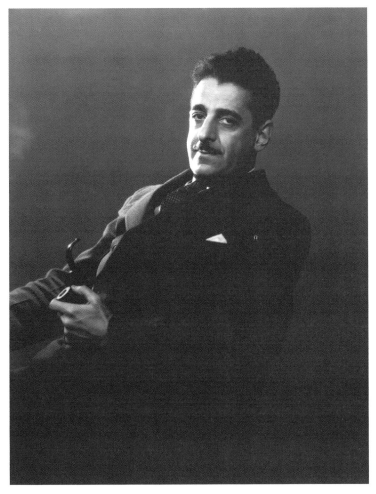

Figure 47 Lee Miller, Alexander Smallens, Conductor (& Music Director), *Four Saints in Three Acts*, New York Studio, New York, ca. 1933

opera, a "new modernism" as one review proclaimed, seemed as much to underscore as to erase the crucial role the casting played in the production's special appeal. For in contrast to the other "real" American opera of the 1930s, Gershwin's *Porgy and Bess* (which *Four Saints* anticipated in the use of an all-black cast and a run on the Broadway stage), the opera has no overt connection to themes associated with African American life and culture.[3] Rather, in a series of

3 *Four Saints* shares more with its "middle-brow" cousin than is usually acknowledged. Gershwin, for instance, was an admiring spectator at the

stylised tableaux, which spans not three but four acts, and involves not four but nearly thirty saints, the opera presents a quasi-religious "baroque fantasy" about the whimsical idylls and visions of sixteenth-century Spanish saints. Dada-esque scenes based loosely on the lives of St Teresa of Avila and St Ignatius of Loyola are enacted, as specified by Maurice Grosser's scenario, on the portal steps of a cathedral, in the pastoral surrounds of a country garden party, and at the seaside in Barcelona. Such bucolic settings would have been familiar touristic spots for American expatriate artists such as Stein and Thomson; and indeed by all accounts they originally conceived of their opera as a kind of allegory of their lives as (queer) artists. As is well known, virtually all of the principal white collaborators – Stein, Thomson, Grosser, Stettheimer, Ashton – as well as their prestigious art-world supporters and salonniers – Van Vechten, A.E. "Chick" Austin, Kirk and Constance Askew – were part of an extensive transatlantic network of queer artists, musicians, and writers.[4]

Why, then, would Thomson desire that an opera ostensibly celebrating queerly resonant spiritual devotion to art through the imaged voices of sixteenth-century Spanish saints be performed entirely by African American singers? What racially mediated relationships and connections between the modern and baroque did the casting propose and perform? Thomson's own statements on this topic have served as the primary source for previous discussions. His explanation for the casting, widely disseminated both before and after the premiere, rehearses familiar tropes of romantic racialist discourse on black sound, albeit with some notable innovations: that African Americans possessed superior tonal qualities of voice, including resonance and clarity of enunciation; that they approached religious subjects with emotional transparency and spontaneity; and that they moved their bodies with "natural" eloquence, style and dignity apparently no longer available to white people, or, at any rate, to cosmopolitan whites. The introduction to the published

Broadway premiere of *Four Saints*, an experience which evidently influenced his decision to employ the choir director Eva Jessye and her singers (as well as conductor Alexander Smallens) for the original production of *Porgy and Bess* the following year.

4 See Steven Watson's *Prepare for Saints* (New York: Random House, 1998) for detailed mapping of the opera's "high bohemian" transatlantic paths through the salons of Stein and Elizabeth de Gramont, duchesse de Clermont-Tonnerre, in Paris, and Muriel Draper, Ettie and Florine Stettheimer, and Kirk and Constance Askew in New York.

libretto quoted Thomson on the subject: "[Negro singers] alone possess the dignity and the poise, the lack of self-consciousness that proper interpretation of the opera demands. They have the rich, resonant voices essential to the singing of my music and the clear enunciation required to deliver Gertrude's text."[5] Countless variations on Thomson's statements circulated in major newspapers, magazines, and press releases. Such sentiments were translated in a 19 February review in *Time* magazine as follows: "The Saints were supposed to be Spaniards but Virgil Thomson had chosen Harlem Negroes because of their diction. White singers, he feared, would act foolish and self-conscious chanting such lines as 'Let Lucy Lily Lily Lucy Lucy let Lucy Lucy Lily Lily Lily Lily ...'"[6]

Putting aside for the moment the primitivist stereotypes voiced in these statements, for audiences of the time (and since) *Four Saints* stretched the boundaries of the genre – principally, its musical and dramatic codes and practices – in multiple directions. The most striking and obvious level through which this happens is that of narrative and language. Stein's playfully experimental libretto is essentially an extended stream-of-consciousness prose-poem that radically eschews linear, "syntagmatic" narrative meanings and time. Scenes run out of sequence, repeat in different order, and go backwards amidst a running stream of prose saturated with repetitions, witty non-sequiturs, and arcane, sophisticated language games.

In his setting, Thomson matches Stein's non-referential strategies through analogous incongruities between text and music, and her absurdist wordplay through an arsenal of musical puns and games. Nothing works as it "should"; Thomson puts conventional operatic forms, tonalities, and textures to ironic and playful use, a mixture of studied simplicity and a celebration of artifice and theatricality. The opening measures of the opera, to take the most immediate example, plunge the listener into a sonic atmosphere redolent of a circus merry-go-round or vaudeville stage: an anticipatory snare drum roll segues into an "oom-pah" waltz vamp, punctuated by the hurdy-gurdy, slightly out-of-tune accents of an accordion. The chorus enters on the words "To know to know to love her so / Four saints prepare for saints"; their phrases, written in four-four time, float off-kilter over the triple-metre accompaniment, a charmingly

---

5 Carl Van Vechten, *Four Saints in Three Acts: An Opera to Be Sung* (New York: Random House, 1934), pp. 7–8.

6 "Saints in Cellophane", *TIME* (19 February 1934): 43–4; 43.

tongue-in-check form of word-painting alluding to 4 [Saints] in 3 [Acts]. This "out of phase" melody and accompaniment become, in effect, a sort of rhythmic joke that disrupts the seeming simplicity of constantly repeating tonic–dominant cadences, creating a playful tonal ambiguity between melody and accompaniment.

The ensuing pages of the opening Prologue bring further contrasts. With the words "In narrative prepare for saints", the texture and dramatic tone suddenly shift: descending natural minor-mode sequences sound plaintively under a lilting melody that continues, now with faux melancholy, the punning on "for/four" as the Saints announce authorial directives. The descending bass pattern would seem to take us into the sonic atmosphere of a baroque lament, yet such dramatic intent is subtly derailed by the harmonic surroundings which fail to obey the downward gravity of the bass line, apparently "getting stuck" while repeating the same chord. The mood soon turns inexplicably from lament to melodrama as the tempo quickens and we hear alternating diminished seventh chords and minor triads moving upwards in parallel voicing. As Stein's number games grow more absurd and the numbers increase to the rhythms of "hide and go seek" ("A saint is one to be for two when three and you make five and two and cover"), the melodic line's clipped speech rhythms climb higher and louder, building to a climax as the chorus erupts on a *fortissimo* diminished chord on the words "A at most". A declamatory passage ensues sung monophonically at octave and unison over silent-movie-style tremolos, while the chorus shouts, "Saint saint a saint. Forgotten saint. What happened today, a narrative." Like so many such passages in the opera, the climactic urgency of the choral outburst ends before it risks being taken seriously, here fizzling out into a surreal monotone chant that begins as a narrative of the "author's'" trip to the country but which soon short-circuits into a kind of parody of operatic recitative, with words spilling out in an breathless stream of grammatical elisions and subordinate clauses for which the main part of the sentence never arrives ("hurrying, hurrying to remain"). Recited in turns first by the Commère, a mezzo, then by the Compère, a bass, the monologue serves also to introduce us to these two central characters, created by Thomson to act as the audience's "host and hostess".

Thomson's score is permeated by allusions to Southern Baptist hymns and vernacular tunes (sentimental songs, marches, dances), and by choral and instrumental textures suggestive of pastoral, Southern spaces. This Southern soundscape, in turn, modulates

the opera's many "non-native" stylistic references (such as the neo-Handelian tropes, chants, and madrigalisms). The resulting mix reverberates over an ambiguous landscape of racial sounds, a landscape that subtly marks the interracial musical terrain of the singing styles associated not only with white Southern revivals but also with African American traditions of congregational singing.[7] Similarly, Thomson's text setting at times suggests affinities between the heightened, complex repetitive speech patterns of Stein's text and the expressive practices of evangelical revival meetings.

Together, text and music foreground what Apollinaire termed "simultanism", the non-discursive "paradigmatic" qualities of language and sound that work to blur the lines between signifier and signified, representation and the real. On this point, through emphasising non-narrative aspects, *Four Saints* simultaneously heightens one of the most central aesthetics of opera: the importance of artifice and performance, of spectacle and theatricality. The Prologue, as the discussion above implies, subverts narrative expectations by directing our focus on the making of the opera itself. A photograph from the Act I Prologue (Figure 92) suggests how the impact of the initial stage images, with their dramatic frontality, worked with the music.

After the anticipatory snare drum roll, the curtain lifted and, "for a moment,, recalled singer and stage manager Thomas Anderson (St Giuseppe), "nothing moved".[8] The design of the opening tableau highlighted a single figure: a Saint cloaked in a heavy, full purple robe posed in a posture of rapture, kneeling with hands outstretched on either side, gazing upwards (El Greco style) against the shimmering bluish-tinted cellophane cyclorama. The stunned air, however, did not last long. As the lights dimmed, a new tableau was established to the opera's opening choral prelude, sung as nearly the entire cast assembled on the stage; the disorienting juxtaposition between the arresting visual design and the absurdly rousing off-kilter sounds and words soon elicited peals of laughter from audiences.

---

7 The apparent confusion around the "identity" of the opera's musical worlds raises the larger and irreducibly "mixed" issues of the musical–racial "origins" of the kind of folk sound and religious hymns Thomson incorporates in the opera, gesturing towards, perhaps, the music's highly complicated and fraught history of interracial exchanges. Such "confusion" also underscores how our understanding of the racial identity of musical styles modulates historically.

8 David Harris, "The Original *Four Saints in Three Acts*", *The Drama Review*, Historical Performance Issue Vol. 26 No. 1 (Spring 1982): 101–30; 102.

Grosser's scenario, structured as a series of *tableaux vivants*, maps an episodic narrative path through Stein's libretto; the successive tableaux present a series of pictorial moments, postcard-like images strung together through sound, movement and gesture. As with Thomson's musical setting, narrative connections between scenario and the text emerge through paths of suggestion or association. And it was crucially the sets and costumes of Florine Stettheimer and choreography of Frederick Ashton that animated these paths with atmosphere, form, and movement.

When Thomson viewed Stettheimer's paintings at her home, he took immediately to their colourful, decorative surfaces, and whimsical social satires, finding in them a sensibility of wit, artifice, and playful innocence that resonated with that of the opera. He would later say: "her paintings were very high camp. […] [H]igh camp is the only thing you can do with a religious subject."[9] Even before concrete plans for the production were under way, Stettheimer began developing ideas in paintings and constructing miniature set models. Thomson's linking of his conception of the opera's religious mise-en-scène with the "high camp" of Stettheimer's paintings is here suggestive of the opera's queer subtexts. Stettheimer's dream-like *Portrait of Virgil Thomson*, 1930, provides another such veiled acknowledgement.

In the painting, Thomson is pictured accompanying himself at a piano, seemingly free-floating inside a dreamlike space filled with blue-, white-, and pink-tinted balloons of clouds. Above the keyboard, Stettheimer inscribed Steinian references to the opera's title; and surrounding Thomson, putti-like are the titles "St Gertrude, St Virgil, St Theresa, St Ignatius". At the bottom of the picture plane, the artist coyly placed her own name as Florine St, at the foot of which is chained a golden lion on a red pillow. The lion along with several other images in the composition would be featured in her designs for the opera, including an arch made of tulle and white doves. One interesting visual element that did not make it into the set designs, however, was a large black pansy that Stettheimer placed prominently in the upper left corner of the painting, floating amongst the clouds of tulle, a pointed reference to Thomson's dissident sexual identity. Not surprisingly, Thomson reacted negatively to this queer detail: "Later in life [...] he admitted to being worried [...] people

9 Quoted in Anthony Carl Tommasini, *Virgil Thomson: Composer on the Aisle* (New York: W.W. Norton, 1997), p. 229.

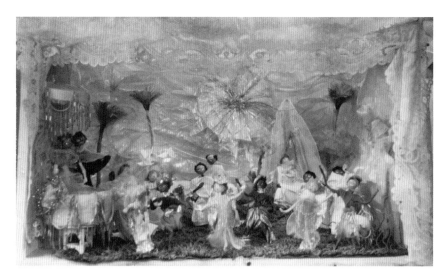

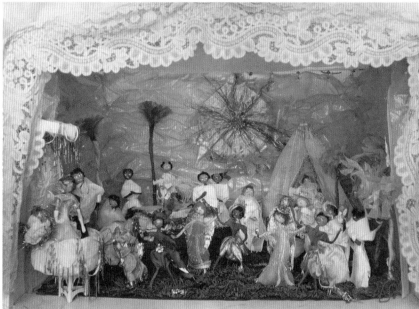

Figures 48–51 Peter A. Juley, Photographs of Florine Stettheimer's puppet and stage models for *Four Saints in Three Acts*. Undated

'would get it.' But friends had assured him that the unknowing never would, and the knowing knew already."[10]

10 Ibid., p. 229. Chief among the knowing friends was of course Van Vechten. Indeed, the flamboyant chain of images quoted at the outset – "divine" black

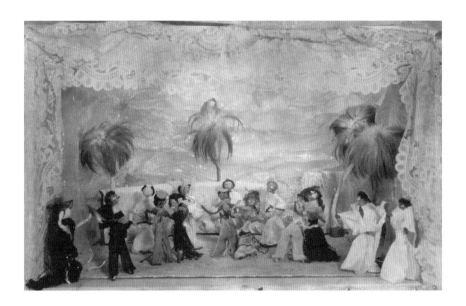

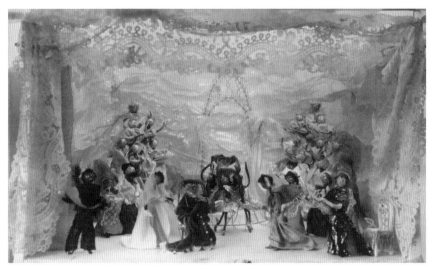

Figures 48–51 Continued

Here, Thomson's fascination with the racial "otherness" of black voices served as an outlet for the projection of a more evanescent dialect: that of the closet. Recasting pervasive "jazz age" racial

bodies, "crinkled sky-blue cellophane", valentine-like "white lace borders", "saints in red velvets", "dark Spanish skins" – is marked by these histories of racialised homoeroticism.

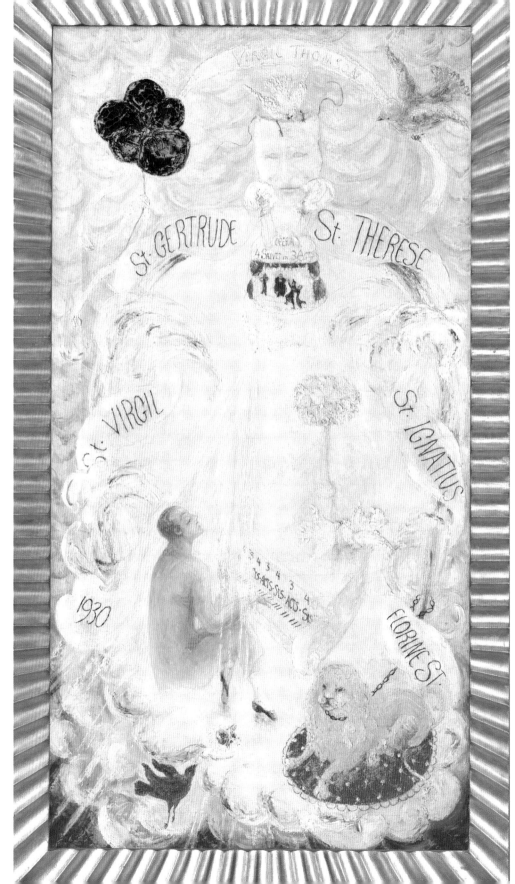

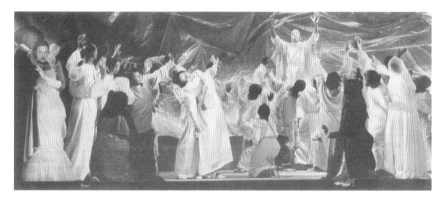

Figure 53  White Studio, *Four Saints in Three Acts*, 'Prophecy scene' Act III, 1934

constructions of the black body as a repository of unfettered, elemental sexuality, primitivist myths about heightened black sexuality provided a cover under which gay men (and women) could safely explore illicit sexual identities. Ashton, inspired by his belief in the inherently ritualistic and plastic quality of black bodies, choreographed movements and poses for the cast that infused the successive tableaux with a sense of mystery, eroticism, and transcendence strongly evocative of the religious spectacles of baroque Spanish paintings. An extant photograph from the Act III "Prophecy scene", for instance, shows St Ignatius (baritone Edward Matthews) standing above the chorus of Saints, his face dramatically framed in high-contrast lighting as he faces the audience, hands held out, palms facing outwards in a posture of blessing.

With the Commère and Compère observing off to the side, the Saints are grouped in a semicircle below as they strike a variety of dramatic poses: gazing up at him, hands lifted in the air, falling to their knees or fainting into the arms of their fellow Saints. In this scene St Ignatius sings the aria "Around is a sound" which is meant to signify his prediction of the Last Judgement. Thomson sets this visionary moment to music that fuses a vocal line comprised entirely of "bugle-call" arpeggiated major triads ("and a round is a sound is a sound and around") with slowly descending pandiatonic harmonies. With the ensuing scenes, the air of solemnity builds: the Commère and Compère's famous "in wed dead lead" dialogue ushers in a religious procession through a mesmerising exchange – part dirge, part tape loop – that brings into close proximity the words "wed"

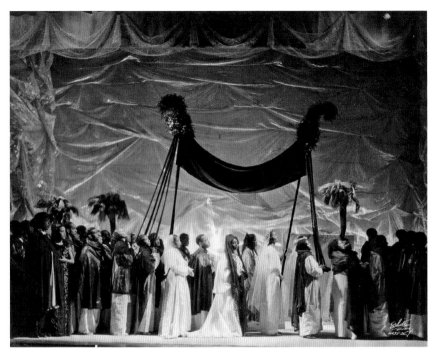

Figure 54  White Studio, *Four Saints in Three Acts*, Act III / Procession of the Saints, 1934

and "dead". In the production the climactic "wedding-funeral" procession was staged underneath a long black canopy with the Saints swaying to and fro, singing uplifting hymn-like choruses.

If the movements and sounds of sacred ritual oriented Ashton's choreographic arrangements for these climactic scenes, for the opera's central dance sequences he turned to a decidedly more contemporary and profane resource – the world of Harlem entertainment. Combining the roles of talent scout and white explorer, Ashton spent many late nights at the Savoy Ballroom observing Lindy Hoppers, six of whom he recruited for the dance sequences. Describing his dance sequences as a combination of "snake hips and Gothic", Ashton's choreography explicitly referenced black dance idioms and styles. The Act II "Angel Ballet" incorporated movements, lifts, and steps from the Lindy Hop, Charleston, and the Snake Hips (a dance created in the mid-1920s by the great Earl Tucker), an effect that one review described as "a high-stepping Harlem ballet" (Figure 37).[11] The dancers' bare skin and erotic

11  "Saints in Cellophane", 43.

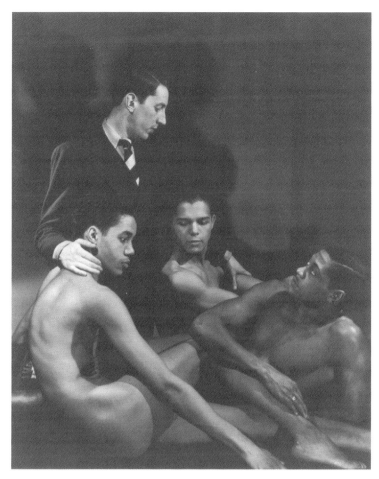

Figure 55  George Platt Lynes, Frederick Ashton with dancers from *Four Saints in Three Acts*, 1934

costumes contrast conspicuously with the veiled bodies of the Saints, who are cloaked in thick white robes.

Echoing Thomson's statements about (and desire for) black cultural resources, Ashton would later recall, "I did *Four Saints* well, because the action was not operatic but ritualistic and ordered [...] because I am devout and the Negroes are devout and I am plastic and they are plastic [...]. [T]hey were never gawky, and though strange always harmonious."[12] As this quote implies, Ashton

12  David Vaughan, *Frederick Ashton and His Ballets* (New York: Alfred A. Knopf, 1977), p. 101. For more on Lynes and homoerotic photography see, for example,

was somewhat more candid than Thomson about the (homo)erotic nature of his attraction to the black body. In fact, this was explicitly captured in two provocative cast photographs taken by George Platt Lynes.

In *Ashton with Actors from Four Saints*, Ashton is posed kneeling, dressed in a dark suit and tie, his head turned down in profile as he gazes upon the naked body of one of the three male dancers, all of whom sit entwined below him (in the manner of a "classical" nude), while Ashton's arms are wrapped around their shoulders with paternalistic benevolence. The photograph obviously reproduces disturbing white fantasies about sexed black male bodies and a strong argument could be made that that is *all* it does; however, Lynes's photograph can also be read, variously, as expressive of a camp (sub)cultural formation or as confronting (literally "laying bare") white male bourgeois subjectivity with its own racial-sexual economy, thus accounting for the discomfort that the images conjure for many viewers.

As the ensuing discussion points up, much of the dramatic force in the original production rested on a visual economy that objectified the cast through what in film theory is referred to as spectacularisation. Here the opera's stylised tableaux provided the perfect vehicle: by de-emphasising forward motion and narrative continuity, the successive tableaux created a kind of fantasy space or "screen" that intensified gesture and body. The performers were framed as simple, childlike, yet mystical figures, intoning a repetitious stream of nonsensical verse, alternating meditative postures of collective worship with irruptive moments of satire. Van Vechten, for example, described the effect of the performance as akin to a

> dream in which you lie back indolently and let things happen to you […]. Possessed by a dozen contradictory moods in as many moments, you fall a prey to conflicting emotions. […] Such a passage as that of the wedding-funeral march scene in the third act, with its sonorous music, its rolling, repetitive text, and its fine pictorial values […] evokes compassion and pity. Such an episode

James Crump, "Iconography of Desire: George Platt Lynes and Gay Male Visual Culture in Postwar New York", in *George Platt Lynes: Photographs from The Kinsey Institute* (Boston: Little, Brown, 1993), pp. 149–55; and Kobena Mercer's comparison of Lynes's work to the racially charged photographs of Robert Mapplethorpe in "Reading Racial Fetishism: The Photographs of Robert Mapplethorpe", in Emily Apter and William Pietz (eds), *Fetishism as Cultural Discourse* (Ithaca: Cornell University Press, 1993), pp. 307–29.

as that in which the Commère and the Compère argue about whether they are going to witness the fifth or the sixth scene [...] [is] richly humorous.

To be sure, what is now typically called "non-traditional" casting has ample precedence in the world of opera, a genre in which singers have customarily taken on roles that cross race, ethnic and gender boundaries. Yet the appearance of "cross-racial dressing" in *Four Saints* presented the audience with a spectacle unique in the operatic repertoire on either side of the Atlantic. Performing a reversal on the customary mapping of racial difference, the original production gave black artists an unprecedented opportunity to play white roles but only *because* they were black.

This fundamental racial paradox, in turn, is reproduced in a related contradiction at the level of form in terms of a tension in the work between its formal experimentation and its deployment of stereotypical representations of blackness. In its anti-representational use of language, heavy doses of self-reflexivity, and lack of conventional narrative, *Four Saints* disrupts the conventions and signifying practices of European opera. From this view, Thomson's bold casting decision may be interpreted as the most radical tactic in the opera's overall avant-gardist aesthetic of disjuncture, a play on expectations that cleverly blurred structures of racial identity and difference, pushing spectators into a liminal space that revealed the "fiction" of America's racial arrangement. At a time in which both opera and whiteness wielded power as undisputed symbols of universal and timeless cultural values, Thomson's audacious move to cast African Americans in "white" opera roles attacked the social and racial presumptions of New York's "highbrow" musical establishment (always one of Thomson's favourite targets). It is especially important to note that one of the most insidious of such presumptions was the racist belief that the anatomical structure of black faces rendered black voices incapable of producing the correct (read white) enunciation to sing opera – a belief that tacitly helped to justify the Metropolitan Opera board's then *de facto* bar on hiring black singers. Viewed in this context, Thomson's public avowal of the expert vocal abilities of African American singers in the area of enunciation was both admirable and courageous. Equally if not more important for the singers in the cast, the production offered a refreshing and disturbingly rare change from the stereotypical repertoire of racial roles available to African American singers in the early 1930s. Thomas Anderson, who

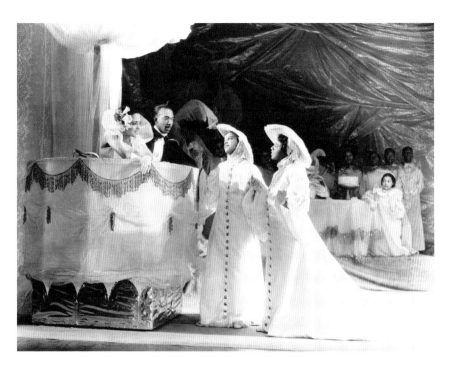

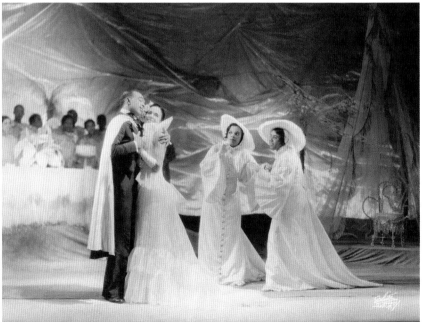

Figures 56–7  White Studio, photographs of stage sets for *Four Saints in Three Acts*, 10 March 1934

both played the role of St Giuseppe and served as stage manager for the production, would later say, "To think you were going to wear something besides overalls [...] instead of falling down on your knees and waving your hands, 'Hallelujah!' It made a big difference in our attitudes."[13]

While it remains important to recognise the positive, even radical aesthetic and social legacies of the original production, we must also be mindful that such instances of identification and inversion can never be lifted out of the social and historical contexts of racism. Here both Thomson's and the audience's identification with black voices and black style, expressed in patronisingly effusive praise, mask a deeper racial logic, one with considerable historical precedence in cultural commentary about black singing. The 1934 performance represented the African American singers not so much as people or actors performing roles but as symbolic objects. The cast acted, in effect, as ciphers for the opera's avant-garde "nonsense", "making the Stein text easy to accept".[14] This collapsing of black difference into modernist aesthetic difference performs a double move: it invests black bodies with seemingly magical power while positioning them as objects of exchange. The perceived blissful, childlike lack of self-consciousness of the cast, then, provided a certain pleasure around communicating race and class exclusion between the "authors" and audience above the head of performers.

Of course the sort of double-edged white investment in black cultural resources such as that found in the production and reception of *Four Saints* defines so much of the history of American music and culture as to be too obvious to bear repeating. Precisely because racial discourses are continually in the process of being negotiated and renegotiated, we need to understand how they have played out in specific historical and social locations. Only in this manner can we make sense of how structures of (racial) difference have shaped – and continue to shape – our individual and collective, public and private selves.

13  Quoted in Tommasini, *Virgil Thomson*, p. 251.
14  Virgil Thomson, *Virgil Thomson* (New York: Da Capo Press, 1967), p. 239.

# 3

## Styling *Four Saints in Three Acts*: scene, costume, fashion, and the queer modern moment

*Christopher Breward*

> The trail of foppishness and pose and pseudo-intellectuality is all over it. [...] Every snob and poseur in town swelled the gathering at the first night.[1]

Olin Downes, famously acerbic music critic of the *New York Times* (unless the subject was his hero Sibelius), was never going to rate Gertrude Stein and Virgil Thomson's *Four Saints in Three Acts* highly, and his appraisal of the opera's opening night on Broadway on 22 February 1934 was more dismissive than many of his reviews. Yet in spite of himself, Downes managed to capture the very essence of the production's shocking appeal and timely aesthetic. For *Four Saints* was, if nothing else, an encapsulation of modernism's fascination with the empty "pose". In its shimmering cellophane lyricism and knowing innocence it reflected all of the contradictions between high and low culture, disparate media and disciplines, tradition and avant-gardism, profundity and superficiality, that contributed to its momentary triumph as a vindication of the supremacy of style and surface over content – made manifest on a 44th St stage at the height of the Great Depression.

1 Anthony Carl Tommasini, *Virgil Thomson: Composer on the Aisle* (New York: W.W. Norton & Co., 1997), p. 260.

Writing five decades later for the sleeve notes of a rare vinyl recording, the rather gentler critic and champion of the "new music theater" Erik Salzman offered a more balanced view. "Modern Art", he advised,

> has a tendency to become "arty". It is an art for connoisseurs. The need to get away from art and artlessness is associated with but not exactly equal to the taste for popular and folk art. "Four Saints" is of course rather sophisticated in its artlessness. Artless (not heartless) […]. More surrealism than realism, more artful than anti-art, but always sincere, good hearted and, well, full of fun.[2]

In this definition Salzman comes closer than Downes did to pinning down the very "fashionability" of this intriguing production, whose distinctive combination of music, dance, scenography, and costume offered a precedent for the later reification of "style" as a creative end in itself. In focusing on those last two elements – the design of set and stage dress and their relationship to contemporary interests in modishness – this essay aims to reclaim *Four Saints* from the purists, celebrating its appeal for the fops, the snobs, and the poseurs, who of course were in the vanguard of modernity, not simply translating it, like Downes, for the newspapers.

In common with the phenomenon of modern glamour, of which it was a striking exemplar, *Four Saints* was conceived of passionately, collaboratively and at a mannered distance, like gossip. The published letters between Stein and Thomson record a fizzing creative exchange in which potential contributors, many of them mutual friends, are assessed and then rejected as the opera takes shape. Stein had originally had Picasso in mind as a stage designer, but in June 1927 Thomson proposed his friend the Parisian painter and fashion illustrator Christian Bérard (whose professional nickname was Bebe); "Bebe", he said "will do decors. He's full of swell ideas. Also wants to give you a picture. You can argue him out of that I think." Stein went further than arguing, finding Bérard's style too vague. As Alice B. Toklas recalled, "Virgil had in his room a great many pictures by Christian […] and Gertrude … used to look at them a great deal. She could not find out at all what she thought about them […] She used to say […] 'they are almost something and then they are just not'."[3]

2 Eric Salzman, "*Four Saints in Three Acts* Again", Virgil Thomson, *Four Saints in Three Acts*, Orchestra of Our Time, Conductor Joel Thome (Nonesuch Digital Recording, 1981).

3 *The Letters of Gertrude Stein and Virgil Thomson: Composition as Conversation* (ed. Susan Holbrook and Thomas Dilworth) (Oxford: Oxford University Press, 2010), p. 37.

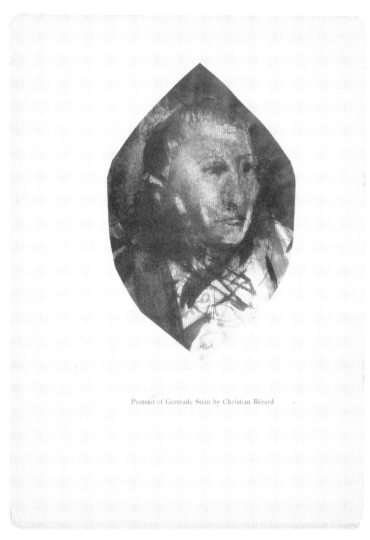

Portrait of Gertrude Stein by Christian Bérard

Figure 58 Christian Bérard, Portrait of Gertrude Stein, from 44th St Theatre programme for *Four Saints in Three Acts*, 1934

In some ways the airy imprecision of Bérard's work was fitting for the religious subject Stein had alighted on. Stein and Thomson moved swiftly through classical mythology and American history, which they both dismissed as overly "heavy". The porcelain figures of Spanish saints decorating Stein's flat gestured them towards the allegorical in which the lives of the saints were, as Thomson remarked, "a parallel to the life we were leading, in which consecrated artists were practicing their art … needing to learn the terrible disciplines

of truth and spontaneity, of channeling their skills without loss of inspiration. That was our theme."[4] This was an obsession shared passionately amongst Stein and Thomson's broader social group, which focused on the Sunday salons of Constance and Kirk Askew at their Park Avenue home. A moneyed socialite and an art dealer, the couple were a formidable cultural force in New York's artistic and bohemian circles of the late 1920s and early 1930s and it was their parties, "held each Sunday afternoon (during the R months, like Oysters)",[5] that brought together the key players in the visual and material realisation of Stein and Thomson's opera, including the Director-Producer John Houseman, Chick Austin, the Director of the Wadsworth Atheneum in which the premiere of the production would be held, and the photographer Lee Miller, who would record its cast, costumes, and sets. The eventual *Four Saints* protagonists mixed with other Askew guests from all aspects of New York's art, music, fashion, theatre, and literature scenes, from Salvador Dalí and Aaron Copland to George Balanchine. It was a veritable melting pot of talent.[6]

As Houseman recalled, the mise-en-scène of the Askew soirées, in which these artists became acquainted, operated in a manner that fell somewhere between 1890s fancy-dress charade and 1960s Factory happening, their atmosphere strangely replicated in the self-consciously pretentious presentation which would find its resolution in the aesthetic of *Four Saints*:

> Through [the Askew rooms] circulated the "notabilities", some four or five dozen, each Sunday, evenly divided [...] between the sexes. They flowed in slowly revolving eddies over the brown-purple carpet, between the massive Victorian furniture. [...] Tea was served, also cocktails and whisky, though never in quantities that would interfere with the serious business of the gathering. Shoptalk was permitted up to a point, so were politics, if discussed in a lively and knowledgeable way. Flirtation (homo- and hetero-sexual) was tolerated but not encouraged.[7]

It was at just such a gathering that Thomson met the artist Florine Stettheimer, whose singular Manhattan vision would come to supplant the Parisian surrealism of Bérard in the design of the opera's

4 Ibid., p. 10.
5 John Houseman, *Run-Through: A Memoir* (New York: Allen Lane, 1972), p. 98.
6 Becky Conekin, *Lee Miller in Fashion* (London: Thames & Hudson, 2013), p. 68.
7 Ibid., p. 99.

Figure 59  Lee Miller, Arthur Everett (Chick) Austin, *Four Saints in Three Acts*, New York Studio, New York, ca. 1933

scenographic and sartorial trappings. The Askews were patrons of Stettheimer, and her febrile, sugary portraits and fantasy pieces adorned their walls. Art historian Linda Nochlin succinctly describes her style as "gossamer light, highly artificed and complex, the iconography refined, recondite and personal".[8] And in his account of

8 Linda Nochlin, "Florine Stettheimer: Rococo Subversive", in *Women Artists: The Linda Nochlin Reader* (ed. Maura Reilly) (London: Thames & Hudson, 2015), p. 133.

the making of *Four Saints*, historian Steven Watson offers a vivid characterisation of her method and reception:

> By applying colors over thick impastos of china-white oil paint, she created the effect of intense light coming from within. Her high-keyed colors, her gilt furbelowed frames, and her willowy figures were sometimes described as naïve, but the more discerning found in her paintings the refined gaiety and humor of Jazz Age Manhattan and the excitement of a Woolworth's window transformed.[9]

Something of this idiosyncratic view on the world also informed the atmosphere and decoration of the Stettheimers' house, Alwyn Court, on the corner of 58th St and 7th Avenue, one block back from the southern entrance to Central Park. Virgil Thomson visited it for the first time in February 1929 and was overawed by its fantastical mix of ornate mouldings, rich draperies, retro nineteenth-century furniture and glittering crystal.[10] Stettheimer's studio overlooking Bryant Park, several blocks downtown, was similarly characterful:

> Its windows were hung with cellophane curtains and the chairs and tables were all white and gold. The tables were glass and gold and there were lamps streaming with white beads and gilt flowers in vases. The windows of the little balcony were hung with Nottingham lace.[11]

Once Stein's text was sufficiently developed, Thomson embarked on a painstaking wooing of the reclusive and highly controlling Stettheimer, understanding that the original aesthetic developed in her paintings and interiors perfectly captured the rococo sensibility of the opera.[12] Through the spring and summer of 1933 he was corresponding with Stein about suitable scenarios for the setting of the action, discarding an early concept for locating it in a Sunday School, for the final *plein-air* expansiveness of Mediterranean cathedral steps, rural garden party, sea shore, and heavenly groves.[13]

9  Steven Watson, *Prepare for Saints: Gertrude Stein, Virgil Thomson, and the Mainstreaming of American Modernism* (New York: Random House, 1998; paperback San Francisco: University of California Press, 2000), p. 72.
10  Ibid., p. 70.
11  Houseman, *Run-Through*, p. 104.
12  Cécile Whiting, "Decorating with Stettheimer and the Boys", *American Art*, Vol. 14 No. 1 (Spring, 2000): 24–49.
13  *The Letters of Gertrude Stein and Virgil Thomson* (ed. Holbrook and Dilworth), pp. 204–11.

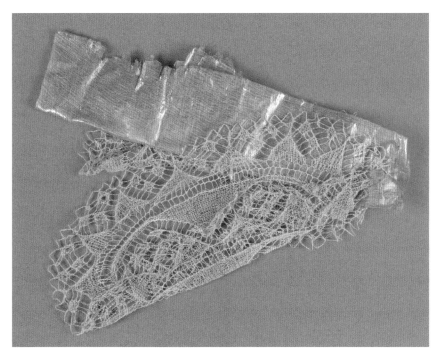

Figure 60 Material used by Florine Stettheimer for maquettes' dresses and stage models

Much of this appears to have originated via the artist's insistence on particular settings and treatments. As Thomson remarked:

> Miss Stettheimer suggested that since any interior is less joyful than an outdoor scene, and since Sunday School rooms and chapels have been done in so many religious plays […] perhaps the same entertainment might take place on the steps of a church, in this case the Cathedral of Avila itself, though represented in a far from literal imitation […]. The colors and materials she suggests are merely an amplification of the fairy tale effect ordinarily aimed at in the construction of religious images out of tin and tinsel and painted plaster and gilding and artificial flowers […]. I must admit I am rather taken by the whole proposal, having seen the extraordinary elegance which Miss Stettheimer has produced in her own rooms with exactly these colors and materials.[14]

By the end of the year, Stettheimer was fully on board as designer, her exotic ideas imparting a painterly influence that placed the visuals of the opera somewhere between the *fêtes galantes* of Watteau,

14 *Selected Letters of Virgil Thomson* (ed. Tim Page and Vanessa Weeks Page) (New York: Schulst Brooks, 1988), p. 106.

Ribera's mystic panoramas, and a Busby Berkeley movie finale. Thomson was ecstatic:

> Miss Stettheimer's sets are of a beauty incredible, with trees made out of feathers and a sea wall at Barcelona made out of shells and for the procession a baldachin of black chiffon and bunches of black ostrich plumes just like a Spanish funeral. St Theresa comes to the picnic in the second act in a cart drawn by a real white donkey and brings her tent with her and sets it up and sits in the doorway of it. It is made of white gauze and has a most elegant shape.[15]

The models of the set, which still survive at the Beinecke Library at Yale University, were constructed as toy theatres or doll's houses, incorporating real seashells, coral, feathers, crystals, and other haberdashery store finds. The cast were represented by six-inch-high wire maquettes, mask-like faces painted on to cork balls, each costume painstakingly designed to emphasise its individuality with coloured nets, chintzes, velvets, lace, foil, moire silk, swan's down, taffeta, pearls, and Stettheimer's signature cellophane.

"In Maurice Grosser's words, it was a Schrafft's candy-box version of Baroque."[16] And yet, underlying the frothy playfulness of the designs was a creative radicalism and purity of intent that was set to produce a landmark event. In his consideration of Stettheimer's costumes for the all-black cast, Thomson betrays a seriousness (if couched in the racist language of the time) that indicates his desire to situate Stein's poetry in the high modernist pantheon of timeless art:

> The Negro bodies, if seen at all, would only be divined vaguely through long dresses. The movements would be sedate and prim, and the transparency is aimed primarily not at titillating the audience with the sight of a leg, but at keeping the texture of the stage as light as possible [...] Naturally, if the transparent clothes turned out in rehearsal to be a stronger effect than we intended, petticoats would be ordered immediately for everybody [...]. If it can be realized inoffensively, the bodies would merely add to our spectacle the same magnificence they give to classic religious paintings and sculpture. One could not easily use this effect with white bodies, but I think one might with brown. My Negro singers, after all, are a purely musical desideratum because of their rhythm, their style and especially their diction. Any further use of their racial qualities must be incidental and not of a nature to distract attention from the subject matter.[17]

---

15 Ibid., p. 221.
16 Watson, *Prepare for Saints*, pp. 224–5.
17 *Selected Letters of Virgil Thomson* (ed. Page and Weeks Page), pp. 106–7.

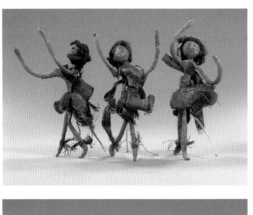

Figures 61–7 Florine Stettheimer, maquettes made for costumes and scenery for *Four Saints in Three Acts*, wire, crepe paper, thread, feathers, sequins, toile, velvet, cellophane, n.d.

Despite Thomson's best interests, as the production of *Four Saints* moved towards its premiere at the Hartford Wadsworth Atheneum, his wish for attention to be directed towards the spiritual core of the opera was thwarted. The complex process of translating Stettheimer's designs to the stage and the increasing public attention

being directed towards its unveiling combined to transform the production into a *cause célèbre*. Houseman recalled the ingenuity of stage manager Kate Lawson in realising Stettheimer's imagination on a grand scale. Most challenging was the manufacture and installation of a cellophane cyclorama of 1,400 sq ft, strengthened by cotton mesh and looped "to give the impression of a grand opera drape ready to soar into the flies at any moment".[18] Lighting designer Abe Feder pushed the technology to its limits, producing a searing "diamond-bright" whiteness for the first act, pastoral light blues and greens for the bucolic second, and a "deeper cobalt of the Spanish sky darkening for the appearance of the Holy Ghost and achieving a livid splendor during the procession in the third".[19]

All was set for a glittering first night in upstate Connecticut. Chick Austin had recently transformed the gallery to meet the curatorial and social demands of the twentieth century, adding the stylish Avery memorial wing in which the theatre sat. Its cantilevered balconies faced into a white marble courtyard in which a mannerist Italian fountain, topped by a naked female deity, provided an elegant counterpoint. The Picasso retrospective concurrently running in the galleries offered further context for Stein and Thomson's play on modernist baroque. In anticipation of the arrival of New York fashionable society, the New Haven railroad laid on extra carriages to its trains for the Hartford afternoon services of 7 and 8 February 1934. As Lucius Beebe, columnist for the *Herald Tribune*, remarked:

> By Rolls Royce, by airplane, by Pullman compartment and for all we know by specially designed Cartier pogo sticks the art enthusiasts of the country descended on Hartford last night in a manner that would have made Mr Keats's fold-bound Assyrians the merest amateurs.[20]

Mrs Harrison Williams, "America's perennial best-dressed woman of the year", certainly lived up to Beebe's description, sporting a cocktail dress that gradually loosened to full-length evening gown as the train journey gave way to the reception and performance; and architect Buckminster Fuller stepped out dramatically with two shimmering socialites on his arms, "one blonde, one dark", from his raindrop-shaped Dymaxion car (enjoying its first public foray) on to

18 Houseman, *Run-Through*, p. 113.
19 Ibid., p. 115.
20 Ibid., p. 117. The allusion is not to Keats but to Byron's "The Destruction of Sennacherib".

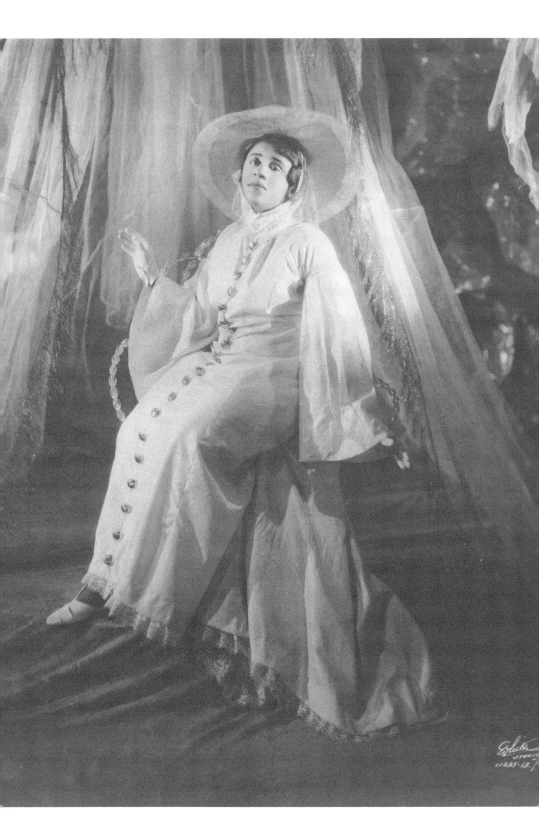

Figure 68 White Studio, Beatrice Robinson-Wayne as St Theresa I in the theatrical production *Four Saints in Three Acts*, 1934

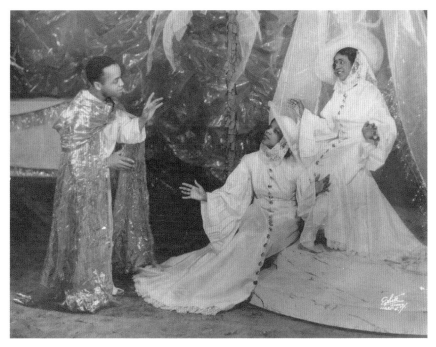

Figure 69 White Studio, Edward Matthews as St Ignatius, Bruce Howard as St Theresa in the theatrical production *Four Saints in Three Acts*, 1934

the museum forecourt.[21] Others dismissed the audience as the sort of "people who walked around with cigarette holders a foot long".[22] But it was the action on stage that really caught the attention of the critics. The art reporter for the *New York Sun* captured the impact:

> When the bright red curtain went up, or, rather, was pulled apart, there was a gasp of astonishment and delight. This audience all knew something about pictures and could see at once that the Saint kneeling in front and clad in voluminous purple silk was quite as ecstatic as anything El Greco had ever devised in that line, and that the costumes of the two Saint Theresas as well as the effect produced by the cellophane background and the remarkable lighting were all addressed to the painter's eye.[23]

21 Ibid., p. 116.
22 Tommasini, *Virgil Thomson*, p. 259.
23 Houseman, *Run-Through*, p. 117.

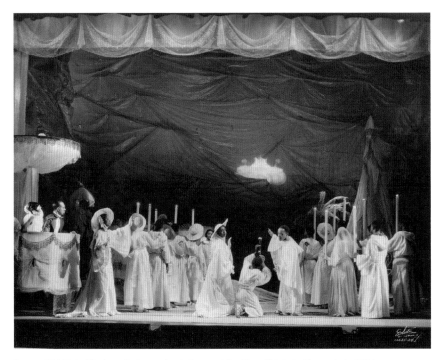

Figure 70 White Studio, photograph of stage set for *Four Saints in Three Acts*, 1934

Within a fortnight of the premiere the production had transferred to Broadway, where Stettheimer's fragile vision faced robust practical challenges. The whole edifice needed to be expanded to have any sort of impact on the much larger stage. With minimal budget Lawson sourced yards of black velvet and new crimson curtains as a more dramatic foil for the cellophane diorama and sunburst, which themselves needed to be remade by "a squadron of seamstresses [...] [who] re-draped the entire firmament in huge festoons that rose fifty feet in the air".[24] Feder had to call on a battery of new light projectors in order to illuminate the whole, and the heat generated from these, in combination with the highly flammable cellophane, almost resulted in the production falling victim to the condemnation of the city's public Fire Marshall. Rapid application of a fire-retardant called "water glass" to all surfaces saved the day and the production moved towards its highly publicised opening night.[25] All of the effort was repaid. Many of the critics recognised its strange and timely

24 Ibid., p. 120.
25 Ibid., pp. 120–2.

contribution to both avant-garde and popular culture. Joseph Wood Crutch summed up the mood in a review in *The Nation*:

> All its elements go so well with one another while remaining totally irrelevant to life, logic or common sense […]. One will find […] the tendency toward form without content and toward a kind of intelligibility without meaning characteristic of surrealism and the Dadaists.[26]

*Four Saints* was then, in its moment, a celebrated critical success, running for sixty performances (longer than any other American opera), before moving on to Chicago that autumn. Gertrude Stein, who had not been able to attend the New York run, arrived with Alice B. Toklas in a plane "filled with American Beauty roses and a sign reading 'a rose is a rose is a rose'".[27] Its legacy, whilst strong for some (Gershwin found inspiration for *Porgy and Bess* through the impact of its cast, and Lee Miller's photographic career took off soon after), was more mixed for others. John Houseman reflected ruefully that, on Broadway at least, "it marked me as a maverick and a highbrow. In the weeks and months that followed I received no offers, no proposals, not even the conversational approaches to a theatrical job".[28] But Houseman's experience perhaps points to the extraordinary originality of the production and its siting in that liminal territory between high art and what would become known in the early postmodern era as kitsch, or camp. The American fashion retail industry, for example, had no hesitation in grasping the opera's commercial relevance.[29] The Fifth Avenue department store Bergdorf Goodman promoted a tea-gown named "Saint" in five colour-ways, while another "advertised a series of mandarin coats made of cellophane with rayon and called '4 wraps in Cellophane'". The advertising copy was a direct homage to Stein's distinctive libretto:

> Might it be silver if it were not cellophane
> Wrap number one red lacquer red red silver lacquer
> Wrap number two in white

26 Judith Brown, *Glamour in Six Dimensions: Modernism and the Radiance of Form* (Ithaca: Cornell University Press, 2009), p. 151.

27 Houseman, *Run-Through*, p. 126.

28 Ibid. p. 128.

29 For further discussion of the ways in which the American fashion system engaged with ideas of modernity in the period see Rebecca Arnold, *The American Look: Fashion, Sportswear and the Image of Women in 1930s and 1940s* (New York and London: I.B. Tauris, 2009), and Linda Welters and Patricia A. Cunningham (eds), *Twentieth-Century American Fashion* (London: Berg, 2005).

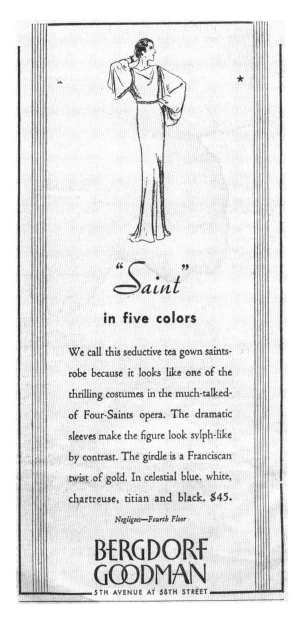

**"Saint"**

**in five colors**

We call this seductive tea gown saints-
robe because it looks like one of the
thrilling costumes in the much-talked-
of Four-Saints opera. The dramatic
sleeves make the figure look sylph-like
by contrast. The girdle is a Franciscan
twist of gold. In celestial blue, white,
chartreuse, titian and black, $45.

*Negligees—Fourth Floor*

**BERGDORF
GOODMAN**
5TH AVENUE AT 58TH STREET

Figure 71 Press advertisement for Bergdorf Goodman, 1934

And bright.
And right.
And quite.[30]

30 Tommasini, *Virgil Thomson*, p. 262.

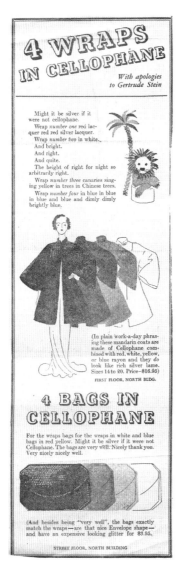

Figure 72 '4 Wraps in Cellophane With Apologies to Gertrude Stein', 12 April 1934, *New York Herald Tribune*

As several scholars have since pointed out, it was the novelty of cellophane and its beguiling use in Stettheimer's sets and costumes that placed *Four Saints* in the vanguard, just as much as its words and composition.[31] In 1934 the material was barely thirty years old,

31 Irene Gammel and Suzanne Zelazo, "Wrapped in Cellophane: Florine Stettheimer's Visual Poetics", *Women's Art Journal*, Vol. 31 No. 2 (Fall–Winter 2011): 14–21.

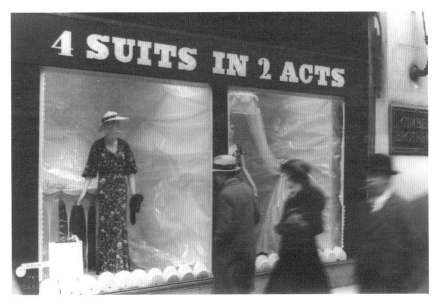

Figure 73 Carl Van Vechten, Windows in Gimbel [Brothers] Department Store, New York, March 1934

having been introduced by Swiss chemist Jacques Brandenberger as a labour-saving solution to soiled cotton tablecloths in an early unsuccessful form in 1904. By 1913 it had earned its trademark name (a syllogistic combination of the organic "cellulose" and "diaphane", to mean transparent) and was being promoted (again, not entirely successfully) in the movie industry as an alternative to the highly combustible cellulose nitrate. But it was its production in the United States as a commercial packaging material from 1924 that sealed its association with glamour, first as a wrapping for Coty perfumes and then as a means to keep confectionary and cigarettes fresh and clean. As the shiny wrapping for a packet of Lucky Strike it took on almost iconic qualities as a material whose translucency and brightness allied it with the inclusive American dream, whilst its surface attractions spoke of the supremacy of the industrial, consumerist construct of modernity.[32] As historian Judith Brown suggests:

> Cellophane [...] as a sign of the new, offered modernists a material with all the plasticity and possibility of language; Stettheimer's set design and Stein's text together spoke in the century's new

32 Jessica Burstein, *Cold Modernism: Literature, Fashion, Art* (Philadelphia: Pennsylvania State University Press, 2012), pp. 12–13.

vernacular, insistently contemporary, to an audience delighted to hear the message.[33]

Brown sets up an opposition between the blankness of Stettheimer's glaringly bright lights and cold, plastic sky and the warm "feeling" black bodies of the actors; between slick modernism and the world of nature. She sees in this a continuation, through the medium of glamorous cellophane, of the colonial impulse.[34] But there is also perhaps a proto-queer aesthetic at play here, which sets cellophane and the baroque appeal of *Four Saints* in more complex play with those themes of sexual and racial identity that are captured in George Platt Lynes's famous portrait photograph of the opera's choreographer Frederick Ashton in full English dandy mode alongside the naked dancers Maxwell Baird, Floyd Miller, and Billie Smith (all of whom appeared in the original 1934 production) (Figure 55).

This is an argument made persuasively by Nadine Hubbs, who counters readings of *Four Saints* as the product of a cool plastic modernism with an emphasis on its highly mannered, decorative obsessions with an eroticised religious nostalgia. The fantastical result might easily have fallen into one of the exemplars presented in Susan Sontag's later, infamous attempt to define the language of "camp".[35] That it didn't doesn't undermine the claim that its style anticipated camp's incongruous mix of high seriousness, theatricality, and knowing humour. Indeed, such characteristics support the placing of *Four Saints* in a long-established lexicon of queer aesthetics. As Hubbs argues, Stein was much influenced by the high-camp novels of Ronald Firbank with their heightened exoticism, and both writers found inspiration in a centuries-old tradition of transcendental Catholic dramaturgy:

> To invoke the sixteenth-century mystic and seer Saint Theresa of Avila is to invoke one of the defining icons of vital passion and ecstatic rapture in the Christian world. It is equally to invoke one of the beloved heroines and patron saints of Western queerdom, a woman who in her life knew intense intimacy with other women and endured on account of her rapturous s/m tinged "visitations", both scandalous rumour and incarcerative scrutiny in the Spanish Inquisition.[36]

33 Brown, *Glamour in Six Dimensions*, p. 152.
34 Ibid., pp. 155–7.
35 Susan Sontag, "Notes on Camp", in *A Susan Sontag Reader* (ed. E. Hardwick) (Harmondsworth: Penguin, 1983), pp. 105–20.
36 Nadine Hubbs, *The Queer Composition of America's Sound: Gay Modernists, American Music, and National Identity* (Berkeley: University of California Press, 2004), pp. 43–4.

Figure 74  Sheet of cellophane, probably used in the original production of *Four Saints in Three Acts*, 1934

Thomson, Ashton, and Stettheimer were equally enamoured with this queer iconography.[37] Theirs was an interest that Hubbs characterises as a "cult of homoerotic community that could be found under the cowl of monasticism"; a cult with roots in early gothic romanticism and *fin de siècle* decadence, anticipating in "its exoticised mysticism and sensuality [...] a resistance to further scorned elements of a contemporary scientific, moralist, progressivist national culture deemed vacuous and provincial".[38] In this context Stettheimer's use of cellophane seems subversive rather than celebratory, an approach that was matched by her uniquely antithetical practices of painting, dressing (she often appeared almost in drag, draped in the hyperfeminised lace and bohemian embroideries of Paul Poiret or attired in masculine clothes) and behaving (as the stories told of her interactions with Thomson, Stein, and other members of the production team of *Four Saints* suggest, she could sometimes be evasive, acerbic, and stubborn) in a society that was otherwise conservative and constraining for single women of her class.[39]

These complex impulses and interrelationships were committed to canvas in a portrait Stettheimer produced of Thomson and the themes of *Four Saints* as their creative partnership developed, following her commission as set and costume designer, but preceding the opera's completion. As Klaus-Dieter Gross records, the painting remained a favourite of Thomson's and hung in his Chelsea Hotel bedroom until his death (Figure 52). His life partner Maurice Grosser described its content:

> I know he didn't sit for it, for it represents Virgil as a much too slim young man seated ecstatically at a white grand piano. Above him hover two doves with a bouquet of violets, while above that a mask of Gertrude Stein manipulates a little puppet show which has "4 Saints" written above it. In the four corners of the picture

37  Ashton's interest can be linked to a concurrent fascination with an eclectic nostalgia shared by his English peers Cecil Beaton, Oliver Messell, the Sitwells, and others. See Alexandra Harris, *Romantic Moderns: English Writers, Artists and the Imagination from Virginia Woolf to John Piper* (London: Thames & Hudson, 2010).

38  Hubbs, *The Queer Composition of America's Sound*, p. 58.

39  Barbara J. Bloemink, "Florine Stettheimer: Hiding in Plain Sight", in Nadine Sawelson-Gorse (ed.), *Women in Dada: Essays on Sex, Gender and Identity* (Boston: MIT Press, 2001), pp. 478–81.

are scrolls or banners, marked respectively St Theresa, St Virgil, St Gertrude and Florine St. It is framed in a silver sunburst and is now in the Art Institute of Chicago.[40]

Here, perhaps, as Gross suggests, all the contradictions of the protagonists "modernist strategies [are] laid bare: Stein's strong self-reflexivity, Thomson's seeking for usable elements in the past, and Stettheimer's parodistic approach. Yet from such a controversial set of aesthetic pre-conditions sprang the first major modernist American opera."[41] That is some legacy for a slight work of plaster saints, cellophane, and feathers, "foppishness, pose and pseudo-intellectuality".[42] Indeed, one could go further to claim that, beyond opera, *Four Saints* presented an entirely new constitution of the meaning of "Style", offering a visual and performative language that would reverberate through queer and popular culture for the remainder of the twentieth century and into the present.

40 Klaus-Dieter Gross, "*Four Saints in Three Acts*: V. Thomson's, G. Stein's, and F. Stettheimer's Portraits of Each Other", *AAA: Arbeiten aus Anglistik und Americanistik*, Vol. 29 No. 2 (2004): 210–11.
41 Ibid., 213.
42 Tommasini, *Virgil Thomson*, p. 290.

# Not so black and white: Frederick Ashton's "outsider" ballet

*Lucy Weir*

It was a terrible task – the most exhausting job I ever did. But it was a great success.[1]

Frederick Ashton's choreography has come to define the terms of English classical dance. His movement aesthetic was characterised by understatement, dry humour, and grace, prizing theatricality and expression above technically "perfect" dancing, and he is the quintessential English ballet choreographer. However, Ashton was a perpetual outsider, and his approach to technique and composition was inspired by a legacy of avant-garde dance inherited from culturally diverse teachers and forebears. Against a backdrop of modernist experimentation in visual art, performance, and music across Europe and the United States, Ashton evolved a new language of dance informed by his multicultural upbringing and unorthodox introduction to classical ballet.

This essay reframes Ashton's early career, exploring the evolution of his style in a broader modernist context, and proposing that his "outsider" status in relation to classical dance allowed him to evolve

1 Ashton, quoted in Zoe Dominic and John Selwyn Gilbert, *Frederick Ashton: A Choreographer and His Ballets* (London: Harrap, 1971), p. 62.

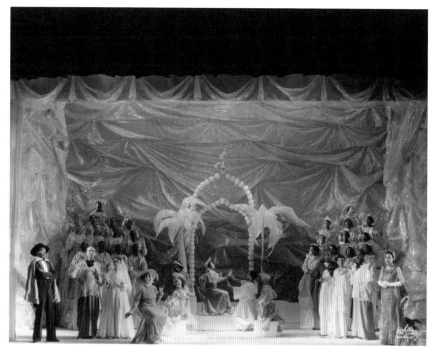

Figure 75 White Studio, photograph of stage set for *Four Saints in Three Acts*, 1934

an innovative, nuanced approach to choreography. It explores the evolution of Ashton's technical approach and the external influences on the young choreographer in the period leading up to his work on Stein and Thomson's *Four Saints in Three Acts* – a crucial turning point in the development of Ashton's approach, synthesising classicism with modern and popular dance techniques.

## Modernity and movement

By the early twentieth century, ballet was established as the primary theatrical dance form in Europe.[2] Classical training remains

2 August Bournonville's eponymous method derived from the French style of ballet, although, since he was a native of Denmark, it became established as a particularly Danish technique. The Bournonville method is unusual in its unsophisticated use of the arms, something that derives from the technique's "pure" legacy rooted in unadulterated nineteenth-century French dance. It emphasises naturalism and harmony between the dancer and the music. The Italian method of ballet was established by Enrico Cecchetti. Cecchetti's rigorous training technique gives special consideration to the dancer's anatomy,

virtually unchanged according to standards first established in the late eighteenth century, though maintaining this status quo has not been without criticism; even by the end of the nineteenth century, ballet was already acquiring a reputation as staid and lacking in expression, likely the result of an increasing reliance on conspicuous virtuosity. However, with the emergence of modernist companies such as Sergei Diaghilev's Ballets Russes, there was increasing interaction between avant-garde artistic circles and the ballet community, and aspects of classical dance rapidly contemporised. Diaghilev advocated a new kind of dance movement that promoted a more obvious image of sexuality onstage. Costumes became more revealing, and performers sought to express the narrative of the dance through whole body movements, rather than miming gestures or relying upon the ballerina's circus-like skills afforded by the use of pointe shoes. Under Diaghilev's direction, the company's ethos rejected standard theatrical norms; the 1913 premiere of Vaslav Nijinsky's *Rite of Spring*, for example, generated outrage among the theatregoing public both for its radical inversion of classical technique and Stravinsky's challenging score, reflecting a growing desire to transcend the limitations of the ballet format.

A palpable shift from the classical technique of Marius Petipa toward a style allegedly more in harmony with the activities of daily life typified early twentieth-century dance.[3] Classical ballet is characterised by the illusion of weightlessness, and it is the task of the dancer to project a magical, otherworldly quality into the theatre setting. However, the growing movement of "free dance" represented by Isadora Duncan on her European and American tours indicated the innate potential of dance to express alternative ideas

and emphasises the importance of the student's individual learning process rather than reliance on imitating the teacher. Finally, Agrippina Vaganova founded the Vaganova (Russian) method, renowned for producing dancers with extraordinary flexibility, strength and expression through its "whole body" approach to training where equal attention is paid to the development of the upper body as to the legs and feet. Differences between these techniques are extensive, and it ought to be noted that other schools of ballet training also exist (the American Balanchine method and Britain's Royal Academy of Dance being two major examples).

3 Petipa was one of the most significant and influential choreographers of classical ballet. He amalgamated French and Italian ballet styles with the Russian technique, and his choreography has survived almost untouched in his versions of the great classical ballets, for example *Swan Lake* (1877), *Sleeping Beauty* (1890), and *The Nutcracker* (1892).

to the unearthly narratives of classical ballet. These abstract dances tended to explore a single concept or image, abandoning the love story ideal that characterised the standardised ballet narrative.

Visual artists were often invited to participate in the creation of ballets, from stage design to narrative concept. Cubist and futurist aesthetics are evident in the stage sets of early Ballets Russes performances, and both Pablo Picasso and Giacomo Balla were regular contributors. Collaborations between ballet companies and noted modernists, such as the work of Natalia Goncharova and Leon Bakst with the Ballets Russes, foreshadowed the increasingly consistent merging of art and dance characterising more radical variants of modern performance; consider, for example, the relationship between Rudolf Laban and Mary Wigman and the Zurich dada group, Oskar Schlemmer's Bauhaus dance experiments, and Robert Rauschenberg's association with Merce Cunningham and Robert Morris's work with the Judson Dance Theatre.

Léonide Massine and Diaghilev's *Parade* (1917) was one of the first (and arguably most significant) of these collaborative dance events, with music by Jean Cocteau and Erik Satie, and stage design and costume by Picasso. Elements of everyday life were incorporated into the ballet, including music hall and fairground imagery. Jazz elements were also evident in the accompanying score, and sequences of tap dance were woven into the choreography, though the female dancers still performed in pointe shoes. *Parade* thus blended potent symbols of modernity and popular culture within a classical framework, paving the way for further inversions of "high culture" on the ballet stage.

Francis Picabia's "instantaneist" ballet *Relâche* (1924) was a similarly radical example of early performance art, its title a dadaist joke referring to a theatrical cancellation.[4] The piece was commissioned by the Swedish aristocrat Rolf de Maré for his Ballets Suédois, rivals of Diaghilev's Ballets Russes. De Maré, an avid collector and connoisseur of visual art, sought to integrate modernist visual art with movement.[5] While nominally termed a ballet, this theatrical work was devoid of traditional dance technique or plot. A cast

4 RoseLee Goldberg, "Performance – Art for All?", *Art Journal*, Vol. 40 No. 1/2 (Autumn–Winter 1980): 369–76; 371–2.
5 Erik Näslund, "The Ballet Avant-Garde I: The Ballets Suédois and Its Modernist Concept", in Marion Kant (ed.), *The Cambridge Companion to Ballet* (Cambridge: Cambridge University Press, 2007), pp. 202–3.

of seemingly random characters took to the stage to accompany the central female character, to an experimental score composed once again by Satie (*Relâche* would in fact be his final work). A wall of car headlights formed the background of the stage setting, suddenly illuminated at the end of the performance to dazzle the audience. Alongside writing the script, Picabia also designed the stage backdrop, and René Clair's film *Entr'acte* – which includes a scene depicting Man Ray and Marcel Duchamp playing chess – was screened during the intermission, the first such screening during a dance performance. As with *Parade*, *Relâche* fused elements of the contemporary avant-garde with everyday movement, popular social dance forms, and bawdy humour, with several dancers only scantily clad. Audiences were shocked and critics were unsparing, but this hybridisation of highbrow and popular culture constituted a vital element of the modernist project.

## The exotic, erotic "other"

Such pivotal interactions between choreographers and visual artists transformed dance performance in the first decades of the twentieth century. Crucially, however, alongside the synthesis of "high" and "low" culture, modernist artists espoused an intense fascination with

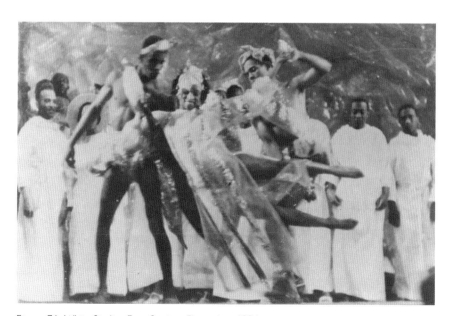

Figure 76  White Studio, *Four Saints in Three Acts*, 1934

exoticism and the non-Western body. Duncan's "Greek" dances, often performed in minimal costume or partially nude, found a natural home in Paris where she garnered acclaim for her sensual modern dance evenings after settling there in 1900.[6] Her aesthetic authenticity is highly contestable, but Duncan's barefoot, anti-ballet improvisations epitomised modernity's rejection of classical purity, and synthesised the unfamiliar exotic with highly sensual depictions of female bodies.

Classical ballet also reflected the broadening interest in exotic themes; Diaghilev's Ballets Russes, for example, generated great enthusiasm for Oriental-inspired ballets such as *Cléopatre* (1909) and *Schéhérazade* (1910). Two large-scale public exhibitions of Oriental art were held in Germany around this time – the Munich Muhammedan Exhibition (1910) and the Berlin East Asian Art Exhibition (1912) – bringing Middle and Far Eastern treasures to eager European audiences.[7] The modernist obsession with exotic, and particularly black, bodies, was both prevalent and problematic. Matthew Pratt Guterl argues that the avid fascination with African art throughout Europe in the 1920s functioned as "a panacea for the 'overcivilization' that had so recently driven the world to war".[8] A significant number of artists of different avant-garde groups explored "African" themes in their work. The mask-like faces of the monumental figures of Picasso's *Demoiselles d'Avignon* (1907), for example, reflect an interest in primitivism shared by contemporaries like Paul Gauguin and Henri Matisse, who recalled purchasing "a small Negro head carved in wood" as a gift for Gertrude Stein, which captured Picasso's attention. This, Matisse claimed, was "the beginning of the interest we have all taken in Negro art".[9] Later, the Zurich dadaists' sound poetry readings were accompanied by drumming and percussion, while Marcel Janco's masks for expressive dance performances at the Cabaret Voltaire were seemingly African-inspired. The Brücke expressionist circle explored 'primitivitist' elements in their strikingly modern, non-naturalistic aesthetic. De Maré was a keen collector of

6 See Samuel N. Dorf, "Dancing Greek Antiquity in Private and Public: Isadora Duncan's Early Patronage in Paris", *Dance Research Journal*, Vol. 44 No. 1 (Summer 2012): 3–27.

7 Suzanne L. Marchand, *German Orientalism in the Age of Empire: Religion, Race, and Scholarship* (Cambridge: Cambridge University Press, 2009), p. 411.

8 Matthew Pratt Guterl, "Josephine Baker's Colonial Pastiche", *Black Camera*, Vol. 1 No. 2 (Summer 2010): 25–37; 25.

9 Jack Flam (ed.), *Matisse on Art* (London: Phaidon, 1972), p. 204.

both African art and modernist European works, and, shortly after staging *Relâche*, he dissolved the Ballets Suédois to begin work on a new revue danced by black performers.[10] In the United States, the Harlem Renaissance heralded a new, mainstream era of black culture that was none the less at odds with the still-widespread practice of segregation. White audiences avidly consumed black music in the form of ragtime and jazz. As the poet Langston Hughes observed, "the Negro was in vogue" in Harlem.[11] From this febrile environment emerged a crucial figure which would yoke together European modernism with African American popular culture.

Josephine Baker, like Ashton, could be termed a perpetual outsider. Born in a poor neighbourhood in east St Louis, she aspired to a life on stage, relocating to New York City where she found work as a chorus girl in the groundbreaking black musical *Shuffle Along* (1921). The revue was enormously popular, running for more than five hundred performances and, to some extent, desegregating mainstream theatres by allowing black actors to perform on Broadway stages. Yet Baker would garner the fame she craved only in Paris, where her star power centred as much on her exotic black body as it did on her impressive stage presence and dance technique. [12]

Baker's celebrity status was solidified by her performance in de Maré's *La Revue nègre* (1925). A publicity storm was consciously generated, and the premiere was attended by such luminaries as Stein, Picabia, Man Ray, and Cocteau.[13] Baker danced in the final scene, but also put on a short performance at the closing dinner, on the same bill as the renowned ballerina Anna Pavlova.[14] The show purported to reflect African American life, featuring a jazz ensemble and an array of song and dance numbers. Baker premiered her cross-eyed Charleston to a delighted Parisian audience. This was a staple of Baker's repertoire, and the most popular social dance form in the USA in the first years of the 1920s (so much so that

10 Ramsay Burt, *Alien Bodies: Representations of Modernity, "Race," and Nation in Early Modern Dance* (London: Routledge, 1998), p. 71.
11 Bryan Hammond and Patrick O'Connor, *Josephine Baker* (London: Cape, 1988), p. 7.
12 In a curious coincidence, in 1925 Henri Roger-Viollet photographed Baker on the roof of Opera Music-Hall des Champs Elysées – the same spot where, one year before, Clair shot Man Ray and Duchamp playing chess for *Entr'acte*.
13 James Donald, *Some of These Days: Black Stars, Jazz Aesthetics, and Modernist Culture* (New York: Oxford University Press, 2015), p. 58.
14 Brenda Dixon Gottschild, *The Black Dancing Body: A Geography from Coon to Cool* (New York: Palgrave Macmillan, 2003), p. 158.

white employers paid a premium for black domestic workers who were able to teach them the requisite steps).[15] Her now infamous *Danse sauvage*, however, perhaps had the most powerful impact, an extremely popular, provocative dance in a skirt made of rubber banana skins. The highly sexualised and overtly exoticised nature of the dance was intended to reflect Baker's African heritage, despite the fact she had never visited the continent. As Baker herself pithily remarked, "the white imagination sure is something when it comes to blacks".[16]

Baker's freedom of movement and unselfconscious attitude to her body marked her out as a unique performer equally capable of portraying seduction and comedy. There are striking parallels with Duncan's popularity in Paris in previous years, and the two shared a tendency to perform nude or partially clothed, revelling in expressive movement free of social constraints.[17] However, Baker was also noted for her impressively fast and complex footwork, though her technical prowess is often overshadowed by discussions of her fetishised black body. In the early 1930s, she received private ballet lessons from Balanchine, and performed his choreography on pointe in 1936 as part of a *Follies* revue.[18] Balanchine, in turn, was deeply fascinated by jazz, and absorbed technical elements from Baker. Black culture thus permeated classical as well as popular stages throughout the early decades of the twentieth century, a fermentation and hybridisation of modernism and exoticism. Even classical ballet underwent a process of modernisation predominantly led by outsiders.

## Frederick Ashton — ballet's outsider

The evolution of modern dance is often distinguished from the development of classical ballet in the early twentieth century. Yet this distinction is not necessarily accurate. While modern dancers sought to diverge from and reject the strict boundaries of ballet, practitioners of both approaches none the less informed one another, creating a

15  Hammond and O'Connor, *Josephine Baker*, p. 11.
16  Baker, quoted in Phyllis Rose, *Jazz Cleopatra: Josephine Baker in Her Time* (New York: Doubleday, 1989), p. 81.
17  Duncan was less pleased with these parallels, stating, "It seems to me monstrous that any one should believe that the jazz rhythm expresses America" (Hammond and O'Connor, *Josephine Baker*, p. 43).
18  Sally Banes, *Writing Dancing in the Age of Postmodernism* (Middletown: Wesleyan University Press, 2011), p. 38.

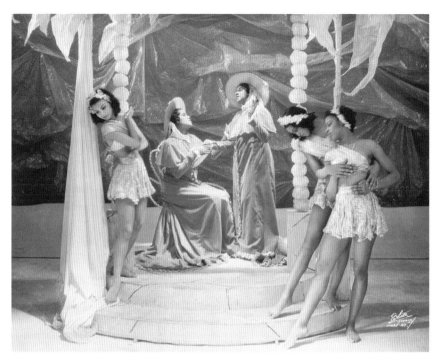

Figure 77  White Studio, *Four Saints in Three Acts*, 1934

kind of interdisciplinary dialogue between classicism and modernity. This relationship would increasingly allow outsiders to influence the aesthetic and technical aspects of ballet.

Frederick William Mallandaine Ashton was born in 1904 in Ecuador, son of the vice-consul of the British Embassy in Guayaquil. An introverted adolescent, Ashton attended a Dominican school in Lima (the family moved to Peru while Ashton was still an infant), where he learned Catholic prayers and "spent an enormous amount of time in church", despite not being raised in the faith.[19] Mysticism and spirituality were integral to everyday life in this deeply religious country. The Lenten carnival was a massive, indulgent celebration and, in October of each year, a parade was held in honour of the miracle associated with the *Señor de los Milagros de Nazarenas* fresco in the Sanctuary of Las Nazarenas, painted by an unknown Angolan slave. The annual procession, a multiracial event, was nevertheless dominated by the Lima's black community. Despite the disapproval of his conservative parents, Ashton immersed himself in the ritual

19  Ashton, quoted in Dominic and Gilbert, *Frederick Ashton*, p. 25.

behaviours of other cultures, and this particular image of visible black spirituality would manifest itself in his work two decades later when choreographing Thomson's *Four Saints*.[20] The influence of Catholic ritual also endured throughout his life – before beginning work on each new ballet, Ashton would visit Brompton Oratory to light a votive candle.

When his parents returned to Guayaquil, Ashton was sent to live with another English family in Lima in order to continue his studies. In 1917, his new guardians took him to a performance by Pavlova at the Teatro Municipal – arguably inspiring Ashton's enduring obsession with ballet (he infamously claimed that, by the end of the evening, "[Pavlova] injected me with her poison").[21] Pavlova was a global celebrity by this point, celebrated for her graceful, elegant and mannered dancing style, and the first female dancer to tour internationally, bringing ballet to countries that had not previously experienced Western classical dance. At the same time, however, her technique was notoriously poor – she had little natural rotation in her hips, her ankles were extremely weak as a consequence of her arched feet, and on stage she regularly broke the numerous strict rules of classical dance. None the less, audiences were captivated by her highly expressive style. She rejected the prevailing trend of the period, favouring minimalist settings for her solo repertoire, most famously *The Dying Swan* (1907), technically a fairly simple piece, choreographed by Michel Fokine, that became synonymous with Pavlova's name as a result of her deeply poignant performance.[22] Her immense joy of movement and dramatic, if imperfect, dance technique impacted heavily on the impressionable 13-year-old Ashton, who, by the end of the evening, had secretly resolved to become a dancer.

In 1918 Ashton was sent to finish his studies at a public school in England. This led to a second, pivotal dance experience when, in 1921, he saw Duncan perform in London. Duncan, quite overweight at this point and her technique weakened, played nightly to diminishing audiences at the Prince of Wales Theatre. Like Pavlova,

20 Julie Kavanagh, *Secret Muses: The Life of Frederick Ashton* (New York: Pantheon Books, 1996), p. 21.

21 Dominic and Gilbert, *Frederick Ashton*, p. 26.

22 More recently scholars have begun reassessing Pavlova's legacy, including Jennifer Fisher's analysis of what she terms Pavlova's "self-branding". See Jennifer Fisher, "The Swan Brand: Reframing the Legacy of Anna Pavlova", *Dance Research Journal*, Vol. 44 No. 1 (Summer 2012): 50–67.

she was performing beyond her peak as a dancer, but her innate capacity to command an audience transcended these physical short-comings. Ashton was struck by her responsiveness to the music and her avowedly anti-classical approach to dance. She performed bare-foot, favouring simple movements and lengthy periods of stillness to reinforce the emotional impact of her choreography. Duncan and Pavlova, while distinct in terms of training and approach, were potent symbols of modernity in dance, and their shared emphasis on emotional content and stage presence above virtuosity would prove crucial for Ashton.[23]

Duncan was another outsider, rejecting what she saw as the "unnatural" foundations of classical ballet (such as the use of turnout and pointe shoes) in favour of an organic, improvised form of move-ment. She stripped complexity from her performances, focusing on emotion and dramatic content projected through movement rather than costume and setting. Though born in the USA, Duncan found critical acclaim for her approach in Europe – her geographical and creative dislocation was also significant for Ashton.

Inspired by Duncan and Pavlova, Ashton successfully auditioned at the advanced age of 20 for Massine, a former protégé of Diaghilev and successor to his star dancer, Nijinsky.[24] With Massine he learned the fundamentals of the Cecchetti method, the dominant style of ballet in England in the mid-1920s.[25] Massine had studied under Enrico Cecchetti, and his lessons integrated the rigour of this tech-nique with the choreographer's own flair. Ashton was thus exposed from the beginning of his training to the importance of individual-ism and expression. Significantly, the relationship with Massine also inducted Ashton into a portentous lineage in dance, linking back to the radical innovations of the Ballets Russes and embodying the twin influences of avant-gardism and classicism.

When Massine left London to rejoin the Ballets Russes, he sent Ashton to train with Marie Rambert, who had been a fellow pupil of Cecchetti. Another late starter, Rambert was not known for her technical prowess (Ashton went so far as to describe her as "a terrible

---

23 Dominic and Gilbert, *Frederick Ashton*, p. 26.
24 Joan Acocella has suggested that Ashton's beginning ballet late in life impacted on his choreography, indicating that the other great innovators of twentieth-century ballet had begun their studies in childhood. See Joan Acocella, "Life Steps", *The New Yorker*, Vol. 80 No. 21 (2 August 2004): 84–5.
25 Geraldine Morris, *Frederick Ashton's Ballets: Style, Performance, Choreography* (Binsted: Dance Books, 2012), p. 13.

dancer"). Like Ashton, she had been profoundly inspired by Duncan, and commenced her studies at Émile Jaques-Dalcroze's school of Eurhythmics in Hellerau, where she would soon be made a member of the faculty.[26] Rambert had a keen interest in modernist dance, and she regularly took her students to modern ballet performances. Through these theatre trips, Ashton was exposed to the work of Bronislava Nijinska, and was struck in particular by *Les Biches* (1924) with its synthesis of classical steps and jazz-inflected hip movements, and air of louche sensuality.

Despite the impressive credentials of Ashton's tutors, his technique was relatively poor, and increasingly his attention turned from performing to creating dance. His early choreographies were mainly formal compositions, and most were rather abstract in terms of plot and characterisation. He prized speed and intricate footwork, sometimes to a degree that was almost unballetic. His characteristic aesthetic would emerge even in these formative works, which were subtle, witty, nuanced, and restrained; there were no fireworks in Ashton's method, as he favoured a more refined, intelligent approach to movement. Instead, he became known for "flourishes, a kind of rushing step akin to Duncan's dramatic feints.[27] Indeed, Ashton owed a significant debt to Duncan, despite her absolute rejection of ballet technique. Following Massine, Ashton embraced his own idiosyncrasies, merging them with his choreographic approach, drawing on the intoxicating personal magnetism of Pavlova and Duncan.

## Four Saints in Three Acts

By the early 1930s, Ashton had garnered acclaim in London for his innovative choreography. He was making work on a regular basis for Rambert's Ballet Club, a company established in 1931 to showcase Alicia Markova as principal dancer and Ashton as performer and choreographer. Works such as *Façade* (1931) demonstrated an avant-garde sensibility in its plotless structure and satirical rendering of popular dance forms. At the same time, however, Ashton's

---

26 During Nijinsky's difficult rehearsal period in advance of the premiere of *The Rite of Spring*, Rambert was brought from Germany to teach the Ballets Russes dancers the Eurhythmics method. See Bronislava Nijinska, Irina Nijinska, and Jean Rawlinson, (eds), *Bronislava Nijinska: Early Memoirs* (New York: Holt, Rinehart and Winston, 1981), pp. 454–5.

27 Jennifer Homans, *Apollo's Angels: A History of Ballet* (London: Random House, 2010), p. 418.

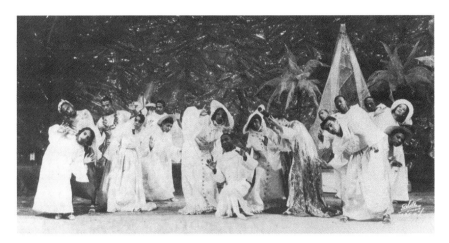

Figure 78 White Studio, scene from the theatrical production *Four Saints in Three Acts*, Hartford, Connecticut, 1934

mischievous sense of humour and theatricality permeated the piece, showcasing his broad knowledge of classical and social dances.

He continued to perform, and was cast in a number of musical revues. In 1932, he appeared in *High Yellow* alongside Buddy Bradley, an African American dancer renowned for his speed and virtuosity in tap dance.[28] Ashton performed in blackface under Bradley's tutelage, but his efforts were, apparently, quite unsuccessful; the impresario C.B. Cochran claimed, "[he] remained a white man despite his makeup and was far too self-conscious and absorbed with the fascination of 'snaky hips' to be convincing".[29] Despite this, Ashton and Bradley collaborated on six shows between 1932 and 1937, and the young choreographer was captivated by Bradley's technique, in particular his polyrhythmy, snaking hips and isolations. This was Ashton's first experience of black dance, and its impact can be seen in a number of subsequent choreographies, including *Les Masques* (1933) and, as Geraldine Morris argues, in the hip movements of the female principal in his 1951 work *Daphnis and Chloe*.[30] A looseness in the upper body was often paired with fast, complex footwork, a possible amalgamation of Bradley's approach and Pavlova's fluid *bourrées*.

28 Morris, *Frederick Ashton's Ballets*, p. 63.
29 C.B. Cochran, quoted in Steven Watson, *Prepare for Saints: Gertrude Stein, Virgil Thomson, and the Mainstreaming of American Modernism* (New York: Random House, 1998), p. 238.
30 Morris, *Frederick Ashton's Ballets*, pp. 64 5.

In the midst of this immersion in popular black dance, Ashton was invited to the USA by Virgil Thomson to choreograph two *divertissements* for a new opera. *Four Saints in Three Acts* was a collaboration with Stein that sought to emulate the style of *Parade*. Eschewing conventional narrative for a collagist structure, they hoped to create "something other than opera".[31] Thomson contacted Ashton by telegram, offering him only a basic fee for his efforts, and eventually the young choreographer set sail for New York to take up this valuable opportunity. More unusual, however, was the fact that Thomson had never seen any of Ashton's choreography; the decision was based purely on instinct after a brief introduction the previous year. [32]

Ashton arrived on 12 December 1933 in New York, where he was launched into the city's febrile dance scene: Martha Graham's stark modern dance stood in sharp contrast to the glamour and theatricality of Broadway, and, from dance halls uptown, jazz was spilling out of Harlem and into theatres and popular shows. Yet he had to overcome the complete lack of professional ballet training in the country. In order to complete *Four Saints*, then, Ashton was a vital import, fusing the influences of classicism and European modernism.

The first rehearsals were not straightforward. Ashton was charged with directing the singers' movement, but claimed that they continually forgot the steps he set – he lamented that work completed in a morning rehearsal would already have been forgotten by the afternoon.[33] Compounding these difficulties, Ashton was asked to recruit dancers capable of performing ballet choreography for his *divertissements*. His solution was found in the infamous Savoy Ballroom, a Harlem institution and the home of Lindy Hop (a high-speed form of swing dance integrating elements of tap and Charleston). Here, Ashton eventually recruited six performers, a combination of professional athletes and dancers including a boxer, a basketball player, a lifeguard, and a taxi driver. None had received any professional training in classical or modern dance techniques.

31  Kavanagh, *Secret Muses*, p. 162.
32  It should be noted, however, that Balanchine was in fact first mooted as the choreographer for this work. His immigration to the United States had been sponsored by the Wadsworth Atheneum, but by 1934 he had moved his school and fledgling dance company from New Haven to New York City, and was thus no longer able to take on the role.
33  Ashton, quoted in David Harris, "The Original *Four Saints in Three Acts*", *The Drama Review*, Vol. 26 No. 1 (Spring 1982): 123.

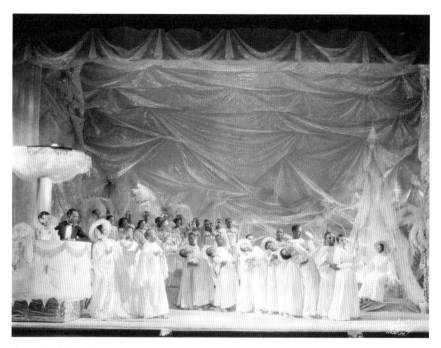

Figure 79 White Studio, photograph of stage sets for *Four Saints in Three Acts*, Act II: All saints at all saints, 1934

In the wake of the Harlem Renaissance, black dance forms were becoming enormously popular with, and increasingly appropriated by, white audiences. By the mid-1930s, Lindy Hop was beginning to move out of black ballrooms and the format altered to accommodate white dancers. Steps became codified and more clearly structured, in opposition to the improvisation central to black and African-derived dance forms. Ashton too had danced "simplified" steps in his collaborations with Bradley. Accordingly, in his choreography for *Four Saints*, he would marry different technical approaches, blending his familiar ballet vocabulary with African American dance and, in particular, the "snake hips" aesthetic he had first learned from Bradley. In recruiting dancers from the Savoy, he further elided popular culture and "highbrow" art, echoing surrealist and dada interventions in dance a decade earlier. The black cast also constituted an important selling point, as Lisa Barg has indicated, drawing on the European fascination with black bodies.[34]

34 Lisa Barg, "Black Voices/White Sounds: Race and Representation in Virgil Thomson's Four Saints in Three Acts", *American Music*, Vol. 18 No. 2 (Summer 2000): 122.

Following a period of intense tuition, Ashton's choreography for *Four Saints* was ultimately playful and light-hearted, emphasising the youthful vitality of his cast. Amidst the classical steps that constitute the basic framework of the *divertissements*, clear elements of Charleston were visible, drawing on the popularity of the form that had travelled from Harlem to Paris through Baker's celebrated improvisations. Rippling movements of the pelvis and circling motions of the arms in opposition to the lower body were likely derived from Bradley's skilful isolations, but are also characteristic of African dance forms. The performers infused Ashton's choreography with their superior and expert command of black dance techniques. Crucially, however, these movements were complete anathema to ballet, where the pelvis and upper body remain held and controlled; undulation of the hips and pelvis would never be seen on a classical stage.

Further stylistic parallels can be drawn between Ashton's *Four Saints* and modernist dance practice. David Harris has linked the "flat, frontal style of composition" to the bas-relief effect of Nijinsky's 1912 work *L'Après-midi d'un faune*, noting that Ashton had seen Nijinsky's piece several years beforehand.[35] It would appear, then, that in *Four Saints*, Ashton drew simultaneously on an array of approaches to dance, blending his own classical training with modernist, experimental choreography, musical revue performance, and popular black social dances. It is a vocabulary that resists categorisation, sitting outside the boundaries of these distinct formats.

Perhaps most significantly, however, Ashton's earliest influences can also be discerned in *Four Saints*. The lack of emphasis on technical perfection allowed for greater emphasis on expression, a tendency drawn directly from the ageing Duncan and Pavlova. Rushing steps and feints are also strongly reminiscent of the former, while the processional formation of the dancers seemed a direct reference to the Catholic rituals of Ashton's childhood in Peru. Indeed, Stein claimed that his Peruvian upbringing and understanding of Latin American Catholicism were vital factors in making the piece viable.[36] Thus, his status as a cultural and artistic outsider found a crucial and fertile outlet in *Four Saints*, a synthesis of modernism and exoticism, cloaked in ballet's classicism.

---

35 Harris, "The Original *Four Saints in Three Acts*": 127–8.
36 Ibid., 130.

# "As if they were the saints they said they were": Gertrude Stein's *Four Saints in Three Acts* and serial resemblance

## John Sears

What is a saint? Why choose saints, and particularly saints like Theresa and Ignatius, as characters in a modern opera? How might one photograph, or write, modern incarnations of sainthood? Underneath the critical questions about meaning and nonsense, intention and reception, inscription and performance, that have preoccupied writers on Stein and Thomson's opera, questions like these remain, answered (if at all) only partly or provisionally. One response involves allegorical interpretation; the Saints of *Four Saints* aren't really saints at all but correspond to Gertrude Stein and figures from her immediate Parisian circle, probably Alice Toklas, or (John Houseman suggests) "James Joyce (or possibly André Gide)".[1] This pins the opera to a particular European context (just as the choice of Spanish setting is usually interpreted as homage to Stein's close friend Pablo Picasso). Saints figured, on the other hand, only occasionally in Harlem Renaissance art and literature. The poet Langston Hughes was explicit in his rejection of Christian saintliness in his 1932 poem "Goodbye Christ" ("And please take Saint Gandhi with you when you go, / and Saint Pope Pius, / And Saint Aimee

---

1 John Houseman, *Run-Through: A Memoir* (New York: Simon and Schuster, 1972), p. 103.

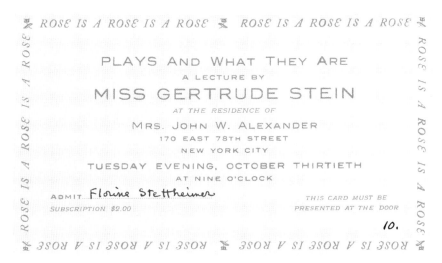

Figure 80 Florine Stettheimer's ticket to Gertrude Stein's lecture *Plays and What They Are*, New York, 30 October 1934

McPherson").[2] Sterling A. Brown published his poem "When de Saints go Ma'ching Home" in Fisk University's *Opportunity: Journal of Negro Life* (Vol. V (July 1927): 48),[3] a poem that (Sonya Posmentier notes) "theorises reading in relation to performance".[4] Thomson and Stein may well have been aware of Brown's poem – *Opportunity* had a wide readership and its circulation peaked at eleven thousand in 1927, when Gwendolen Bennett, who had socialised with Stein in Paris in 1926, was its assistant editor. Whether this important African American poem influenced Thomson's decision to employ African American singers is unclear. Brown certainly knew later of their *Four Saints*, noting its importance for "acquaint[ing] Americans with the rich potentialities of the Negro in musical drama" in his 1951 essay on black achievement or recognition in "Athletics and the Arts".[5]

2 Langston Hughes, "Goodbye Christ", in David Levering Lewis (ed.) *The Portable Harlem Renaissance Reader* (New York: Viking/Penguin, 1994), pp. 266–7.

3 See Robert B. Stepto, "'When de Saint Go Ma'ching Home': Sterling Brown's Blueprint for a New Negro Poetry", *Kunapipi*, Vol. 4 No. 1 (1982): 94–105. The poem is the source of the title of a major anthology of African American culture, Michael S. Harper and Robert B. Stepto's *Chant of Saints: A Gathering of Afro-American Literature, Art and Scholarship* (Chicago: University of Illinois Press, 1979).

4 Sonya Posmentier, "Blueprints for Negro Reading: Sterling Brown's Study Guides", in Cherene Sherrard-Johnson (ed.), *A Companion to the Harlem Renaissance* (Oxford: Blackwell Books, 2015), pp. 119–36; p. 126.

5 Sterling A. Brown, "Athletics and the Arts", in *A Son's Return: Selected Essays of Sterling A. Brown* (Boston: Northeastern University Press, 1996), pp. 99–135; p. 114.

The photographers of the cast of *Four Saints* propose different, again provisional, solutions to the question of the saint, suggesting in their photographs different conceptions of sainthood deriving from traditions of the saintly icon, ranging from the austere blocks of light and dark characterising Lee Miller's portraits (Manichean saintliness, playing to the limits and potentials of the medium and drawing on Miller's considerable expertise in lighting her subjects), to the flowery, baroque ornateness of those of Carl Van Vechten (saintly and domestic naturalness, external decoration implying the moral simplicity and honesty within, drawing on Van Vechten's habitual

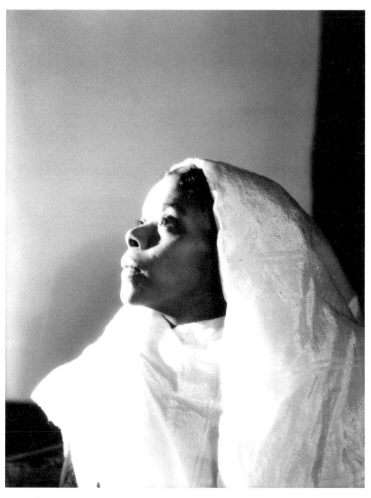

Figure 81  Lee Miller, Bertha Fitzhugh Baker as St Settlement in *Four Saints in Three Acts*, New York Studio, New York, ca. 1933

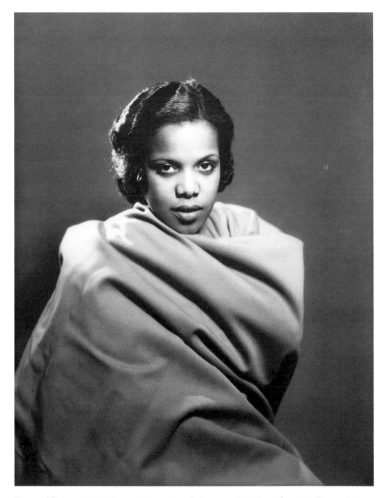

Figure 82  Lee Miller, Bruce Howard as St Theresa II in *Four Saints in Three Acts*,
New York Studio, New York, ca. 1933

portrayal of subjects in simulated, floridly decorated drawing-room settings). Miller portrays her subjects in austere sackcloth or bare-torsoed, performing a kind of saintly repudiation of earthly luxuries such as comfortable clothing; Van Vechten's subjects wear their onstage costumes, suggesting another, overtly theatrical kind of performance of an enacted, coded saintliness.

Both sets of portraits suggest vying conceptions of the "theatrical mask" that sainthood might be.[6] Posture, gesture, facial alignment,

6 Alexander Irwin, *Saints of the Impossible: Bataille, Weil, and the Politics of the Sacred* (Minneapolis: University of Minnesota Press, 2002), p. 222.

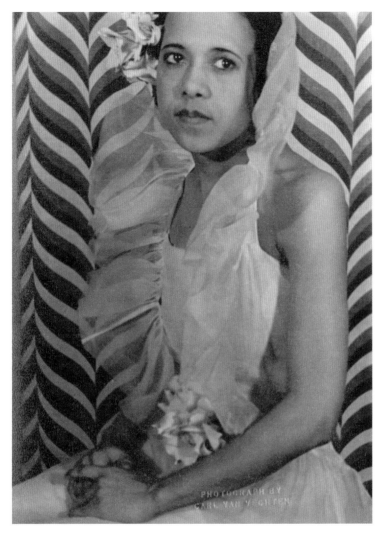

Figure 83 Carl Van Vechten, Altonell Hines as the Commère in *Four Saints in Three Acts*, 9 March 1934

the gazes of the subjects (sometimes abstracted offstage, into-the-distance, sometimes staring directly into the camera lens and thus returning our gaze, as if our own failure to perform saintliness were coming under gentle scrutiny), hand positions, the framing of the portraits (cropped to head and shoulder in those by Miller published in the *Four Saints* programmes) – all work to construct a modernist-inflected conception of sainthood as visible and visual, a to-be-looked-at-ness of the sanctified that plays through reflection

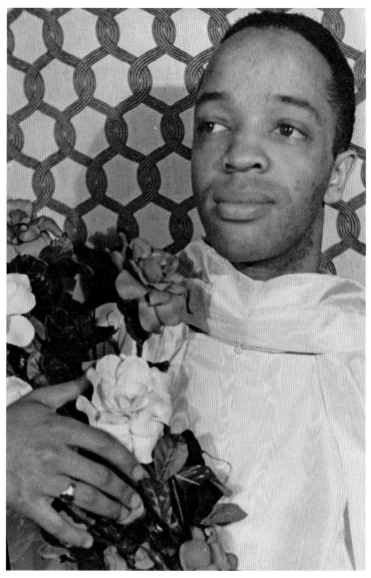

Figure 84 Carl Van Vechten, Edward Matthews as Compère in *Four Saints in Three Acts*, 1934

on the connections between visionary experiences and saintly conversion. Jean-Luc Nancy emphasises that "the portrait appears dedicated to the job of resembling" and thus "most emphatically bears the trace of a function or a service [...] to truth that is never too far removed from a sense of religious service"; and nevertheless

that "the portrait is also quite distinct from the religious icon".[7] Everything in these portraits speaks, through the emphasis on enactment, of this close but distinct relation between (secular) portrait and (religious) icon, suggesting that we might reframe the question of the modern saint in terms of performance. What, then, does *Four Saints* do, and what do Stein's Saints do? How does Stein conceive of the Saint – what is the Saint for? And, in photographing the cast in costume and posing in theatrically saintly poses, what do the photographic portraits of *Four Saints* do with notions of the saintly?

We can read *Four Saints* as partly focused on the acts performed by written and photographic portraiture. It offers a kind of portrait through multiple perceptions of the Spanish St Teresa of Avila (1515–82), whose writings present (Bárbara Mujica argues, in her recent biofiction) "the image of a complex and contradictory woman".[8] Stein alludes also to Bernini's *Ecstasy of Saint Theresa* (1647–52, Santa Marie della Vittoria, Rome), a photograph of which was included in the *Four Saints* programme, and which influenced Lee Miller's portraiture for the show. Through the portrayal of St Teresa, Stein also creates a thinly veiled portrait of her partner Alice B. Toklas, nicknamed "Thérèse"[9] by Stein early in their relationship. Toklas's name is embedded in the opening repetition of Stein's text ("*To k*now *to k*now to love her so", readable as "Tok now, Tok now, to love her so"), reinforcing Ulla F. Dydo's reading of this text as a response in 1927 to Stein and Toklas's recent relationship troubles, as if Stein was returning from other concerns to deal in her writing with *Tok now*. In her "If I told Him – A Completed Portrait of Picasso" (1923), Stein had written of "exact resemblance to exact resemblance",[10] defining through insistence or repetition the infinite relation of the portrait to its sitter (a resemblance cannot be exact; an identical copy is still not the thing itself). Stein's Theresa "resembles" both St Teresa and Toklas, but only in the sense that words can

7 Jean-Luc Nancy, "The Look of the Portrait" (translated by Simon Sparks), in Simon Sparks (ed.), *Multiple Arts: The Muses II*, (Stanford: Stanford University Press, 2006), p. 228.

8 Bárbara Mujica, *Sister Theresa: A Novel* (Woodstock and New York: The Overlook Press, 2007), p. 371.

9 See Ulla F. Dydo, *The Language that Rises* (Northwestern University Press, 2003), pp. 193–4.

10 Gertrude Stein, "If I Told Him: A Completed Portrait of Picasso", in *Look at Me Now and Here I Am: Writings and Lectures 1911–45*, ed. Patricia Meyerowitz (Harmondsworth: Penguin 1971), p. 230.

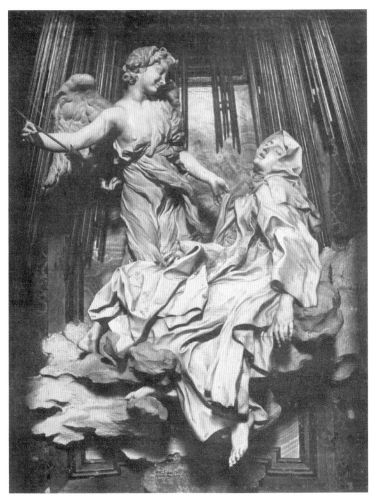

Figure 85 Gian Lorenzo Bernini, *The Ecstasy of Saint Theresa*, 1647–52, reproduced in Hartford and 44th St Theatre *Four Saints in Three Acts* programmes, 1934

resemble the things they signify; that resemblance, in turn, works in multiple and ambiguous ways, none of them exact.

Stein wrote extensively on her verbal portraits of people and things. Many of her most experimental works are attempts to portray in words fictional or fictionalised characters and key figures in her life, including Picasso and Virgil Thomson, both of whom reciprocated, portraying her in their respective media. Thomson portrayed Stein musically; their mutual depictions of each other were included in the Hartford *Four Saints* programme. "Dear Gertrude, it still resembles

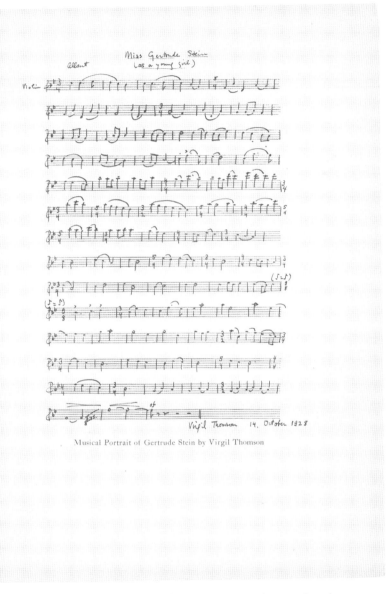

Figure 86  Virgil Thomson, musical portrait of Gertrude Stein, Miss Gertrude Stein (as a young girl), 14 October 1928, reproduced in Hartford and 44th St Theatre *Four Saints in Three Acts* programmes, 1934

# PORTRAIT OF VIRGIL THOMSON

### BY GERTRUDE STEIN

Yes ally. As ally. Yes ally yes as ally. A very easy failure takes place. Yes ally. As ally. As ally yes a very easy failure takes place. Very good. Very easy failure takes place. Yes very easy failure takes place.

When with a sentence of intended they were he was neighbored by a bean.

Hour by hour counts.

How makes a may day.

Our comes back back comes our.

It is with a replica of seen. That he was neighbored by a bean.

. Which is a weeding, weeding a walk, walk may do done delight does in welcome. Welcome daily is a home alone and our in glass turned around. Lain him. Power four lower lay lain as in case, of my whether ewe lain or to less. What was obligation furnished furs fur lease release in dear. Dear darken. It never was or with a call. My waiting. Remain remark taper or tapestry stopping stopped with a lain at an angle colored like make it as stray. Did he does he was or will well and dove as entail cut a pursuit purpose demean different dip in descent diphthong advantage about their this thin couple a outer our in glass pay white. What is it he admires. Are used to it. Owned when it has. For in a way. Dumbfounded. A cloud in superior which is awake a satisfy found. What does it matter as it happens. Their much is a nuisance when they gain as well as own. How much do they like why were they anxious. None make wishing a pastime. When it is confidence in offer which they came. How ever they came out. Like it. All a part. With known. But which is mine. They may. Let us need partly in case. They are never selfish.

These quotations determine that demonstration is arithmetic with laying very much their happening that account in distance day main lay coupled in coming joined. Barred harder. Very fitly elephant. How is it that it has come to pass. Whenever they can take into account. More of which that whatever they are later. Then without it be as pleases. In reflection their told. Made mainly violet in a man. Comfort in our meshes. Without any habit to have called Howard louder. That they are talkative. Most of all rendered. In a mine of their distention. Resting without referring. Just as it is. Come for this lain will in might it have taught as a dustless redoubt where it is heavier than a chair. How much can sought be ours. Wide or leant be beatific very preparedly in a covering now. It is always just as lost.

Harden as wean does carry a chair intake of rather with a better coupled just as a ream.

How could they know that it had happened.

If they were in the habit of not liking one day. By the time they were started. For the sake of their wishes. As it is every once in a while. Liking it for their sake made as it is.

Their is no need of liking their home.

Figure 87 Gertrude Stein, 'Portrait of Virgil Thomson', reproduced in Hartford and 44th St Theatre *Four Saints in Three Acts* programmes, 1934

you, love, Virgil", Thomson wrote on the handwritten red chapbook copy of his *Miss Gertrude Stein, Portrait, for Violin Solo* that he presented to Stein, now held by Yale's Beinecke Library (he also wrote a musical portrait of Alice Toklas). In the lecture "Portraits and Repetition",

one of the talks she delivered to the University of Chicago in 1934 after attending the November production of *Four Saints* in that city, Stein meditated on her philosophical interpretations of William James's theories of perception and their influence on her development of a theory of the written portrait as a way of reproducing something of the individual "sitter" without merely attempting to repeat their appearance, trying to capture instead something of "life" as an effect of simultaneity: "at once talking and listening [...] like the motor going inside and the car moving",[11] as she puts it. Understanding Stein's theory of the portrait involves grasping that her desires to avoid repetition in portraiture, and to escape from the confines of resemblance and remembrance in seeking to capture the portrayed object or person in the act, are ways of erasing narrative from (or at least drastically reducing its significance in) writing.

The portrait becomes for Stein a generic space in which the artist can explore the possibility of escape from narrative sequentiality into modernist logics of simultaneity and juxtaposition. Where novels that rely on narrative offer, in their familiarity and traditionalism, a kind of repetition – "more of the same much more of the same"[12] – the portrait potentially offers an escape from this kind of repetition, towards a position of privileged insight into the person being portrayed. "I wrote portraits knowing that each one is themselves inside them and something about them perhaps everything about them will tell some one all about that thing all about what is themselves inside them", Stein writes.[13] Her St Theresa (minus the French accents) is revealed, in the stuttering, insistent language of *Four Saints*, as one who performs acts that reveal the ways in which she is "herself inside her" – that is, her identity is revealed to the reader or audience through the set of insistences and organising contrasts – seeing and acting, being and doing, singing and saying, landscape and portrait, male and female saints, etc. – by which *Four Saints* is structured, and through the exaggerated linguistic stuttering of the textual surface.

Stein's writing is, of course, famously opaque (John Houseman, reading *Four Saints* "zealously", found it was "becoming familiar but not intelligible"),[14] ridiculed by early critics but now recognised as

---

11  Stein, "Portraits and Repetition" in Stein, *Look at Me Now and Here I Am* (ed. Meyerowitz), p. 102.
12  Ibid., p. 110.
13  Ibid., p. 103.
14  Houseman, *Run-Through*, p. 101.

subversively creative, even revolutionary in its implications – she is "the greatest experimental writer in American literature", according to Richard Kostelanetz.[15] Its repetitions, grammatical elisions and twists, its playful use of alliteration, rhyme, and pararhyme, its deliberate refusal of conventional syntax, its resistance to paraphrase or explication – all combine to situate it amongst the most demanding of modernist oeuvres, influenced as much by painting as by avant-garde literary traditions. A short passage from the start of Act III of *Four Saints* demonstrates many of these stylistic idiosyncrasies, and, while part of the substantial portion of text cut by Virgil Thomson when he edited Stein's published work down as a libretto, nevertheless both illustrates and prepares the reader for some of the ways *Four Saints* works:

> Did he did we did we and did he did he did he did did he did did did he did did he did be categorically and did he did he did he did he did he did he in interruption interruption interruptedly leave letting let it be be all to me to me out and outer and this and this with in indeed deed and drawn and drawn work.[16]

Here, repetition and alliteration are pushed to extremes, with the past tense "did" insisting (Stein's preferred term for "repeating")[17] throughout, modulating after 20 instances (and after the literal interruption of "interruption interruption interruptedly") into "leave", "letting let it be be" (implying in the ambiguity of "leave" both departure and tolerance) – then back, via, the recentring of the consciousness of St Theresa ("be all to me") to "indeed deed" ("deed" from Old English *daed*, a doing, an act) before the closing repetition, "drawn and drawn work", which cements the passage's theme to a notion of pictorialism, of visual representation, as a kind of "work" (opera, again). The repetition of "did" has furthermore the potential to collapse when read into repeated "ids" ("id-id-id"), suggesting a kind of unconscious pressure, an *id* uttering its otherness, its idness. Stein's writing here offers an extreme version of the kind of stuttering, a collapsing of sense and grammar into articulated inarticulacy which is simultaneously productive, a breaking-out from linguistic codes and constraints, that illustrates what Gilles Deleuze means by

15 Richard Kostelanetz, "Preface", in Kostelanetz (ed.), *Gertrude Stein Advanced: An Anthology of Criticism* (Jefferson: MacFarland, 1990), pp. xi–xii; p. xi.
16 Gertrude Stein, *Four Saints in Three Acts*, in *Writings 1903–1932* (ed. Catharine R. Stimpson and Harriet Chessman) (New York: Library of America, 1998), p. 647.
17 See "Portraits and Repetition", pp. 101–2.

"the writer who becomes *a stutterer in language*", in a language that "lets an unknown foreign language escape from it".[18]

Stein's notion that the portrait "tells" of the "themselves inside them" of its subject differs radically from the traditional objectives of portrait photography as defined by (for example) Julia Margaret Cameron: "my whole soul has endeavoured to do its duty towards [my subjects] in recording faithfully the greatness of the inner as well as the features of the outer man".[19] Stein's portraits seek to *do* different things: not to record but to allow a verbal feature or act which is both a partial detail ("something about them") but also potentially total ("perhaps everything about them") to act metonymically to connote "that thing" that is "themselves inside them". This avoids the problem of a figure like St Theresa, of whom any attempt at pictorial resemblance would be absurd; but the "acts" that Theresa "performs" in *Four Saints* scarcely resemble "acts" in any conventional sense. Linda Simon notes that "Virgil Thomson […] sees St Theresa reaching 'high sexual delight' in having 'had it with a spoon'"[20] in Stein's text; such encrypted innuendo apart, the reader is presented with what seems less a mobile sequence of performed acts that "transforming performance into static tableaux", as Corinne E. Blackmer puts it.[21] Instead, it is Stein's language that performs in *Four Saints*, its stuttering enacting the stretching of sense within the formal constraints of scenes. The opera's overt references to its own construction exaggerate this sense of stasis in tension with the fluid intermingling of words, grammatical functions, and connotations, and the language performs its own instabilities. Far from beginning, proceeding, and ending, we begin, over and over (echoing Stein's famous instruction to the young Hemingway: "Begin over again, and concentrate").[22]

18  Gilles Deleuze, "He Stuttered", in *Essays Critical and Clinical* (translated by Daniel W. Smith and Michael A. Greco) (London: Verso Books, 1998), pp. 107–14; pp. 107, 113.

19  Julia Margaret Cameron, "Annals of My Glass House", in Liz Heron and Val Williams (eds), *Illuminations: Women Writing on Photography from the 1850s to the Present* (London: I.B. Tauris, 1996), pp. 8–14; p. 12.

20  Linda Simon, *The Biography of Alice B. Toklas* (Lincoln: University of Nebraska Press, 1978), p. 327 n. 29.

21  Corinne E. Blackmer, "The Ecstasies of Saint Theresa: The Saint as Queer Diva from Crashaw to Four Saints in Three Acts", in Corinne E. Blackmer and Patricia Juliana Smith (eds), *En Travesti: Women, Gender Subversion, Opera* (New York: Columbia University Press, 1995), p. 332.

22  Gertrude Stein, *The Autobiography of Alice B. Toklas* (London: Penguin Classics, 2001), p. 230.

The organisation of *Four Saints* around a series of structuring parallels further enhances this sense of formal stasis, of solidity around which language swirls. If the basic opposition is, conventionally, that between portrait (of St Theresa, St Ignatius, and the other Saints) and the landscapes of Spain (with, perhaps, the fluid shape-shifting hamadryads of Picasso's *Paysage aux deux figures* of 1908 in the background), *Four Saints* also exploits tensions between being and doing, beginning and ending, seeing and being seen, and the different modalities of could and would. Insistent lexical puns push the stuttering text further – "seen" ("may never have seen the day") is repeatedly confused with "scene" (which assumes a verbal function when used by Thomson as a sung stage direction), "singing" echoes "women" as "window" suggests "widow", and Theresa blurs into "trees" ("No one surrounded trees as there were none") as the pair of Theresas designated by Thomson in the libretto is echoed by the pear tree. A further level of orthographic punning occurs with the appellation "Saint Paul Seize", which may be read as "sees" and thus as confluent with "season" (summer, winter etc.) or, in French, as rhyming with "says" (thus counterpointing singing) and signifying the number 16.[23]

This punning demonstrates the text asserting its own linguistic performativity. When Virgil Thomson wrote (in his autobiography) that the performers acted "as if they were the saints they said they were",[24] his double appeal to simile (as if) and claim (they said they were) echoes this textual performance, deflecting into an assertion of pure enactment both intention and appearance, and locating the authority of the illusion of sainthood within the performance itself, redirecting it away from any intention on the part of himself or Gertrude Stein and on to the performers, who appear "as if they were the saints they said they were". The clause (notably a perfect, aesthetically rounded iambic pentameter) is profoundly Steinian in its repetitions, its circular yet wholly familiar syntax allowing three "theys" in the space of ten words, dramatically emphasising the performers as distinct others.

In the April 1927 edition of *transition*, two years before *Four Saints* appeared, Stein published a short piece titled 'An Elucidation', which became the prefacing text to *Portraits and Prayers* (an anthology of her shorter texts also published in the key year of 1934).

23 Stein, *Writings 1903–1932*, p. 612.
24 Virgil Thomson, *Virgil Thomson* (New York: Da Capo Press, 1967), p. 239.

Here, as Ulla F. Dydo notes, she "refuses to explain writing and to distinguish theory and practice".[25] "This", Stein announces early in the text, "is a new preparation".[26] She later advises the reader: "Do prepare to say Portraits and Prayers, do prepare to say that you have prepared portraits and prayers and that you prepare and that I prepare".[27] Stein is referring to the work of preparation of the writer and the reader for the works (portraits and related pieces) eventually comprising the book this text will preface. Her meaning, echoing "Prepare for Saints", from the opening phrase of *Four Saints* (and source of the title of Steven Watson's book), extends however to the preparation for the summation in one volume of her extended writerly inquiry into the difficult relation between pictorial and literary depiction of the human subject – between portrayal and description, between showing and telling.

"Preparation" is thus multiple in its implications – a performative injunction demanding that we prepare to read (this coming book), prepare to "see" (the objects of these written portraits), prepare to hear (these "prayers"), prepare to experience and consider (these literary experiments). "Preparation" becomes itself a kind of performance – a insistent or emphatic "doing" like the "doing" of the double injunction "Do prepare", or the "doing" that is writing ("You know I just did an opera about St Theresa and Loyola", Stein wrote to Van Vechten in August 1927).[28] "Opera", "prepare", "prayer", "portrait" – there is much lexical play between these terms, so "prepare" is a near-anagram of "opera", and a rhyme of "prayer", while all play with each other's alliterative and assonantial potentials, which are exploited by repetition structured or destructured by degrees of variation and addition. The stage debut of *Four Saints* was marked by the first publication of an abridged version of Stein's *The Making of Americans*, the huge narrative she had written largely before 1911 and which had been published in full in a limited edition by Contact Press in 1925. William H. Gass surely has a sense of the distinctions and connections between "Portrait" and "Prayer" in mind when he advises the reader of *The Making of Americans* "how

25 Ulla E. Dydo (ed.), *A Stein Reader* (Evanston: Northwestern University Press, 1993), p. 431.
26 Stein, "An Elucidation", *transition* (April 1927): 246.
27 Ibid., p. 263.
28 Stein to Van Vechten, 11 August 1927, in *The Letters of Gertrude Stein and Carl Van Vechten 1913–1946* (ed. Edward Burns) (New York: Columbia University Press, 2013), p. 152.

important looking as well as listening are to the understanding and appreciation of prose".[29] Looking, listening, doing, preparing, praying, portraying – the work (*opera* derives from the Latin *opus*, work) implied by this network of interconnected or overlapping verbs provides a way into thinking about and considering the saints portrayed in Stein's opera; and the portraits exhibited in *4 Saints* are, after all, portraits of people performing versions of sainthood, through costume, gesture, pose, gaze, lighting, bodily orientation, and other visually encoded meanings. They are less portraits of people, and more portraits of people portraying, being "the saints they said they were". A key element of Stein's writing demands a kind of extended posing, a presentation of the self through external acts that relates in productive ways to how photographers elected to portray (illustrate) the opera's figures. The accoutrements of photographic portraiture combine, in this relationship, into different forms of "doing", different kinds of performed identities, as each figure is photographed and rephotographed in different enactments, different poses of the performed self in a kind of portrayed serial repetition that is analogous to the characteristic repetitions and variations of Stein's prose. As the near-anagram Saint–Stein suggests, we are close also to thinking about and considering the function of Stein herself – as a corpus, a body of texts to be seen, listened to, portrayed, prepared, and, perhaps, prayed to.

Doing and being, drawing, work – act, portrait, and opera – are all thus embedded in, and to an extent performed by, Stein's stuttering writing. Each insistent "did" and "deed" differs from the others in force, in its place in the sequence (the first connoting differently from the last and from all the others; each differentiated from the other, as Jacques Derrida insists, by temporalisation and spacing, by occupying slightly different times and spaces as they are read or spoken).[30] Each apparent repetition is thus (Stein would insist) a variation, a demonstration of how every inscription or utterance of a word is necessarily different from all the others – "a moment by moment insistence" in which "each moment of insistence is a heightened and refreshed recognition", as Donald Sutherland writes of Stein's most

29 William H. Gass, "Foreword" to Stein, *The Making of Americans* (Normal: Dalkey Archive, 1995), p. vii.
30 See Jacques Derrida, "Différance", in *Margins of Philosophy* (translated by Alan Bass) (Chicago: University of Chicago Press, 1982), pp. 3–27.

famous repetitive sentence, "A rose is a rose is a rose".[31] We might read such differences as minimal linguistic versions of the kinds of differences of identity with which the pictorial (photographic or painterly) portraitist is concerned – as a textual equivalent of the kinds of modernist sequentiality familiar from Eadweard Muybridge's stop-motion photography, its influence on Duchamp and other earlier painterly experimenters, and (less directly, but no less palpably) on the portrait practices of those photographers (represented in this exhibition) who documented in sequential portraiture the cast and crew of *Four Saints* (as discussed in Patricia Allmer's essay).

The oscillation between verbs of doing and verbs of being, between identities as actively performed qualities – things we *do* – and identities as active modes of existence – things we *are* – organises Stein's writing generally and *Four Saints* in particular. The stuttering "did", emphatically past tense, is yet intransitive, simply a completed doing rendered incomplete by the opening effect of repetition, generating in *Four Saints* a vital sense of identity in process that is manifest throughout Stein's text and through the complex identity politics that dynamised the early performances of the opera. As Charles Bernstein notes of Stein's own complex engagement with the politics of identity (as a Jewish American lesbian living in Paris), the potential inclusivities of a notional Americanness (rather than the exclusivities of any potential selfhood) are her ultimate object of enquiry, "if" (Bernstein writes) "we take America to be a movement away from given identities and toward something new, unapproachable, unrepresentable, and unattainable".[32] The complex networks of identity, American and international, involved in the production of *Four Saints* find expression in the complex elusive meanings and saintly utterings – stutterings – of Stein's writing.

31 Donald Sutherland, "Gertrude Stein and the Twentieth Century", in Kostelanetz, *Gertrude Stein Advanced*, pp. 4–17: p. 10.
32 Charles Bernstein, "Stein's Identity", *Modern Fiction Studies*, Vol. 42 No. 3 (1996): 485–8; 487.

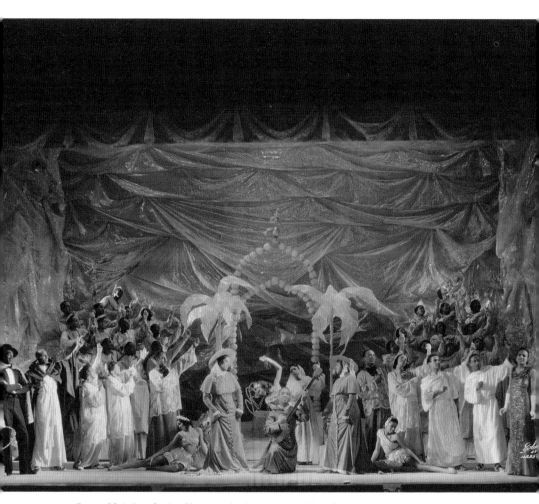

Figure 88  White Studio, Photograph of stage set for *Four Saints in Three Acts*, 10 March 1934

6

# The visitable past:
# *Four Saints in Three Acts* remembered

*Steven Watson*

*Four Saints in Three Acts* fascinated me long before I heard a recording or saw a production of the opera. Since then I have listened to three recordings and seen six productions, and I remain intrigued.

I was initially drawn to *Four Saints* as a cultural touchstone of the interwar period. It was an American *Gesamtkunstwerk*, singular in its form, exemplifying a radically avant-garde spirit that resonated on both sides of the Atlantic. Unexpectedly, the opera became a popular success when it was produced in Hartford and New York City in 1934. It quickly became the most widely reported cultural event of the decade, not to mention the longest-running opera to play on Broadway. I know of no other blockbuster phenomenon since the Armory Show introduced modernism to America in 1913. I decided in the late 1980s to examine the events and dynamics that resulted in *Four Saints*.

When writing history, conducting interviews with participants is certainly not the most efficient method, nor the most objective. But the process encourages a personal dimension of understanding, what Henry James called "the visitable past". Planning an interview is not unlike planning a political strategy. Virgil Thomson was the key collaborator still alive to interview. He not only suggested to Gertrude Stein the idea of writing an opera and wrote the music,

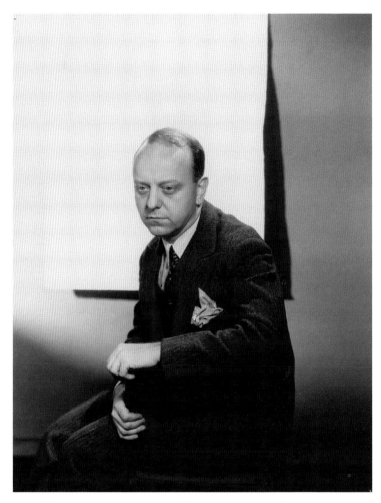

Figure 89  Lee Miller, Virgil Thomson, Composer, New York Studio, New York, ca. 1933

but also functioned as the indefatigable engine that, over a period of seven years, organised its production. Rather than approaching him directly, I wanted to be introduced by a mutual acquaintance. I contacted Monroe Wheeler, who had known Thomson for decades. He had been the director of exhibitions at the Museum of Modern Art, and his two most long-term lovers were the photographer George Platt Lynes and the novelist Glenway Wescott. Monroe was generous of spirit and celebrated for his charm; there would be no enmity between him and Thomson, who had alienated many people over the years.

I arrived at Thomson's apartment on the sixth floor of the Chelsea Hotel, then home to a youngish bohemian crowd (see Andy Warhol's *The Chelsea Girls* (1966)), rock musicians, and a few notables like Thomson, who embodied the elder generation. He had lived there for decades surrounded by art made by such friends as Maurice Grosser, who created the scenario for *Four Saints*, and Florine Stettheimer, who had designed its sets and costumes and painted Thomson's portrait. Dominating the main room was his grand piano, with books piled on top. In front of this stood a large pale gold wingback chair brocaded with sage green ornaments, a sort of throne in which he would read, issue orders to an assistant, and nod off after lunch.

During my first meeting, Thomson was welcoming and so relaxed he candidly expounded his pet theory that the New York City music world was run by Eastern Jews, and that he had been excluded because of his Midwestern Protestant background; he seemed not to care that his ideas could be interpreted as anti-Semitic. Within a week he sent me a plain white postcard expressing pleasure in our meeting and closing, "Everbest, Virgil Thomson".

I was surprised when I entered his apartment the second time. He looked testy and the interaction soon grew rocky. Thomson's voice had a bark and a bite. Because he was severely deaf, he sometimes misunderstood me. "I get the impression that you are stupid", he said, and later added, "You don't know what you're talking about". I curtailed the interview. A year passed before I ventured to contact him again. Instead of fishing for general cultural information, I came this time with a clear plan: to understand the social interactions that led to the 1934 premiere of *Four Saints in Three Acts*. Henceforth, over a half dozen interviews, he fully responded to my questions, largely because he enjoyed reliving the late 1920s and early 1930s, probably the happiest period in his long life. When I transcribed his comments, I was struck by his canny, shapely, orderly paragraphs, punctuated by conclusions that were often provocative, a reflection of his Missouri roots plus his transatlantic cosmopolitan experience.

Thomson recounted a pivotal evening that affected the casting of the opera. After spending an evening in Harlem in 1933, he concluded that the cast should be composed entirely of African Americans, not because the opera concerned black life but because black singers possessed superior diction. His evening's companion, Henry-Russell Hitchcock, suggested that he should sleep on that idea, but when he awoke the next morning he arrived at the same conclusion.

After I had tracked down the four performers still alive from the 1934 production, I realised that there could be an effective documentary film tracing the creation of *Four Saints*. I knew nothing about making a documentary, but I realised that by the time I learned how to do it all the principals would be dead. I hired a skeletal camera crew, filmed hours of interviews, and the result fourteen years later was a television documentary, *Prepare for Saints: The Making of a Modern Opera*, widely broadcast over several years on PBS stations. This led to my personal motto: shoot people while they are alive, figure out later how to use the footage. Following that rule I have shot hundreds of hours of oral histories.

In the early 1930s, there were certainly famous black singers (Ethel Waters, Cab Calloway, Bessie Smith) and dancers (Bill "Bojangles" Robinson, John Bubbles). Although Thomson sought less professional performers, he insisted that his singers should be able to sightread music, and such experience was in short supply among African Americans. Most learned by the rote method, in which a choir leader sang and the rest repeated until the music was memorised. A supposed exception was Eva Jessye, who had led her singers in King Vidor's 1929 film *Hallelujah*, and later, in 1935, trained the singers for *Porgy and Bess*. When I interviewed her in 1985, she was an obese woman in her mid-eighties, seated in a wheelchair, exuding charisma and jollity. She took great pleasure in recounting how she had fooled Thomson into thinking her choir could read notes. When he came to her home he had insisted on it. Jessye told him to return the next day for an audition. "My motto is, 'What I don't know today I might know tomorrow, because I always have the night between'."

She rehearsed the choir by the rote method, so they knew at least some sections perfectly. When they performed the next day, she recalled, "They hit that music at ninety miles an hour". She said Thomson exclaimed, "I've never seen such sight reading in all my life!" They were hired on the spot, and relished the challenge of Stein's experimental libretto yoked to music unlike anything they had ever sung. "We really went abroad on that", Jessye said. "Up to that time the only opportunities involved things like 'Swanee River', or 'That's Why Darkies Are Born', or 'Old Black Joe'. They called that 'our music,' and thought we could sing those things only by the gift of God, and if God hadn't given us that gift we wouldn't have any at all. With this opera we had to step on fresh ground, something foreign to our nature completely." She

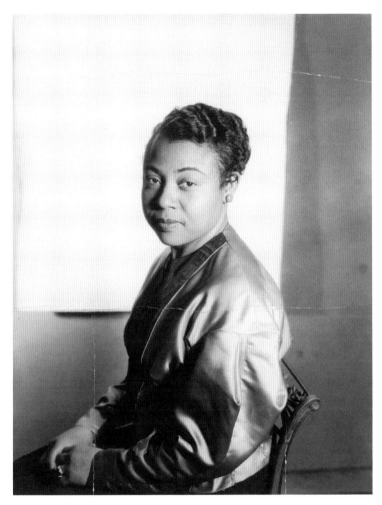

Figure 90 Lee Miller, Eva Jessye, Choir Director of *Four Saints in Three Acts*, New York Studio, New York, ca. 1933

demanded that her singers be paid for rehearsal, which was not a customary practice, and that meals be served during rehearsals to ensure the singers showing up. Jessye and Thomson sometimes clashed during these rehearsals. He sometimes had to take over to ensure the singers didn't turn his sophisticated score "into those kind of rowing-a-boat rhythms".

Beatrice Robinson Wayne, who filled the prominent role of St Theresa I, was the last person to be cast. She recalled an early set-to with Thomson, when she thought he didn't like her singing, and she confronted him, "Why are you looking at me like that?" After

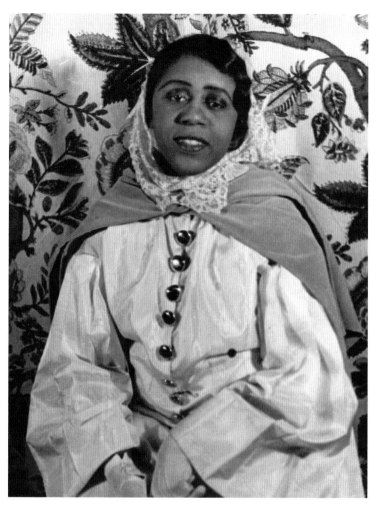

Figure 91  Carl Van Vechten, Beatrice Robinson-Wayne as St Theresa in *Four Saints in Three Acts*, 9 March 1934

that incident there were no problems. She would spend her evenings sitting up in bed with the opera score, not merely memorising her difficult part but fully absorbing it. I interviewed her the first time in a nursing home in Queens; her surroundings were bleak and her spirits low. When I returned with my camera crew, she seemed to be a changed person, a diva made up for theatrical lighting with hair carefully coifed, and dressed in a richly coloured gown, basking in the extra attention the staff paid her as a special person. She said that she had prayed for the day to go well, for us and for Virgil. She could still remember her solos fifty years later.

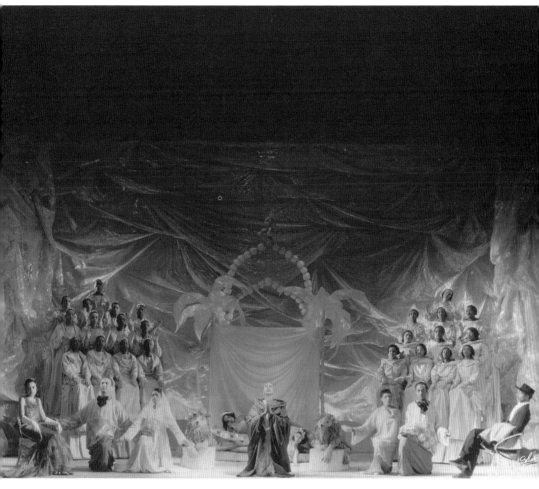

Figure 92 White Studio, photograph of stage set for *Four Saints in Three Acts*, 10 March 1934

Thomas Anderson (universally known as Tommy) played the small role of St Giuseppe. Unlike many of his fellow cast members, Tommy continued as a working actor in film and television, ending his career playing Michael Douglas's butler in *Wall Street*. Before the shooting, I had alerted him for what subjects the documentary would cover. He created scenes that were genuine but dramatically heightened. He also insisted on doing several takes until he was satisfied; it took four for the shot in which the 81-year-old clambered up from his knees to demonstrate the stature *Four Saints* had bestowed on African Americans. Despite his heroic efforts, I thought Tommy's outsized "scenes" would seem hammy. I was

wrong; audiences embraced his actorly delivery as essential to who he was.

Kitty Mason was the opposite of Anderson, a sweet, self-effacing woman who played the role of St Cecilia in 1934. (Although the role was minor, it marked the Broadway debut of Leontyne Price in the opera's 1952 revival.) Kitty was especially pleased that she was one of the first to master the section "Let Lucy Lily", which constantly shifted the three words with no discernible reason or order. When she and Tommy Anderson showed up for filming the documentary at St Philip's church on 133rd Street (where the original cast had rehearsed fifty years earlier) she was wearing a modest knitted hat, which she declined to take off because she didn't want to reveal her hair. ("Tommy has gotten so old!" she whispered to me, and Tommy later whispered, "Oh! Kitty looks so old", as if the fifty years since they last saw one another shouldn't have made a difference.) At the close of the day Kitty showed me her programme from the 1934 production; the cover was ragged but the interior pages were intact, and all of the cast had signed it. "No one has asked me about this, not even my children", she said. "So now is the time to give it. To you. But let me look at it one last time." She slowly turned the pages, and after each she said "Bye bye. Bye bye."

7

Gallery

Figures 93–4  The Empire Theatre New York cast list and schedule from *Four Saints in Three Acts* programme, 1934

Figure 95 Auditorium Theatre Chicago, cast list from *Four Saints in Three Acts* programme, 1934

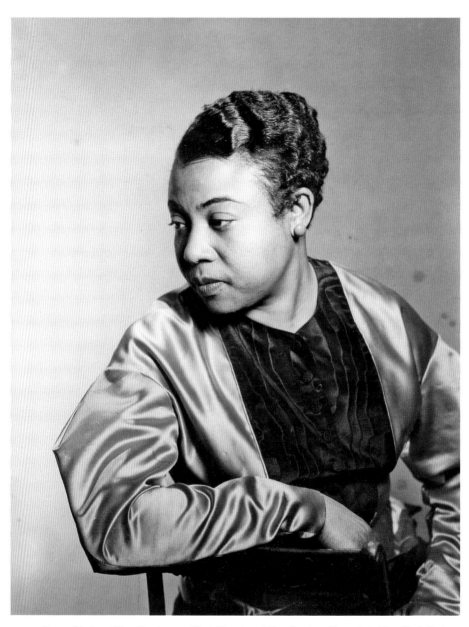

Figure 96  Lee Miller, Eva Jessye, Choir Director of *Four Saints in Three Acts*, New York Studio, New York, ca. 1933

Figures 97–9  Lee Miller, Altonell Hines as the Commère in *Four Saints in Three Acts*, New York Studio, New York, ca. 1933

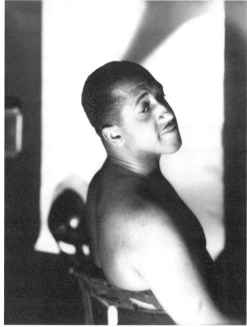

Figures 100–1  Lee Miller, unidentified performer from *Four Saints in Three Acts*, New York Studio, New York, c. 1933

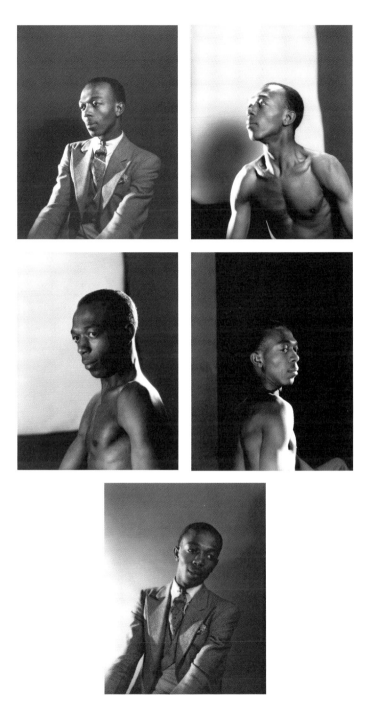

Figures 102–6  Lee Miller, Abner Dorsey, Compère in *Four Saints in Three Acts*, New York studio, New York, ca. 1933

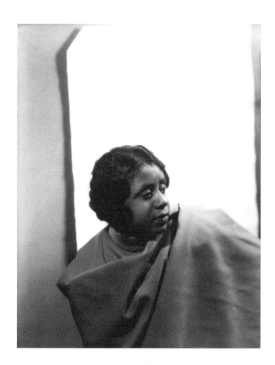

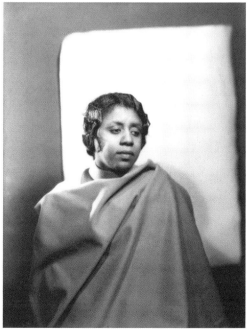

Figures 107—8 Lee Miller, Beatrice Robinson-Wayne as St Theresa I, *Four Saints in Three Acts*, New York Studio, New York, ca. 1933

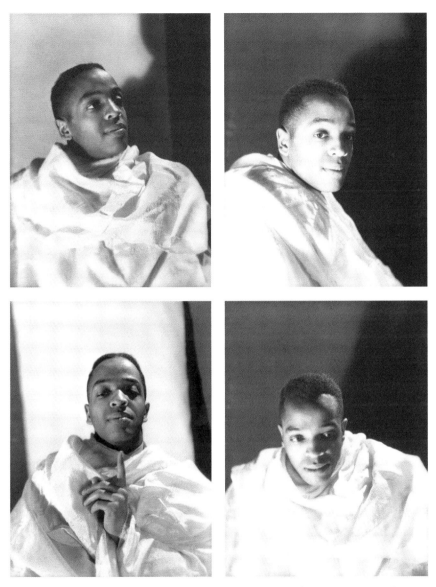

Figures 109–12  Lee Miller, Edward Matthews as St Ignatius, *Four Saints in Three Acts*, New York Studio, New York, ca. 1933

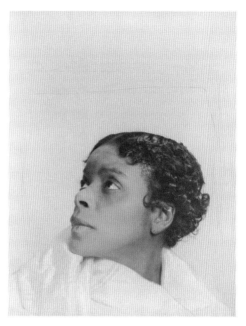

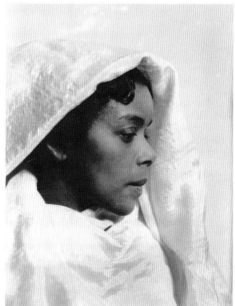

Figures 113—14  Lee Miller, Bertha Fitzhugh Baker as St Settlement in *Four Saints in Three Acts*, New York Studio, New York, ca. 1933

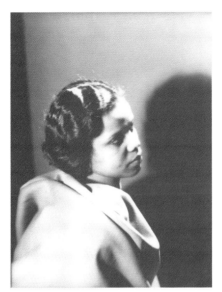
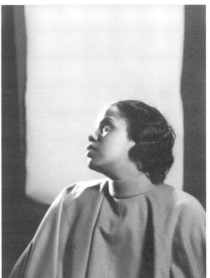
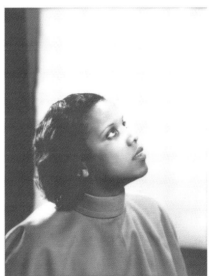

Figures 115–17  Lee Miller, Bruce Howard as St Theresa II in *Four Saints in Three Acts*, New York Studio, New York, ca. 1933

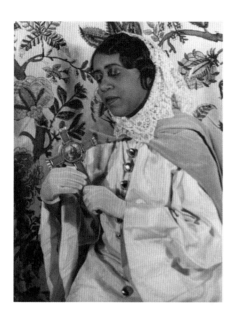
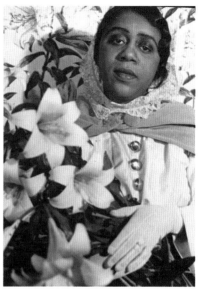
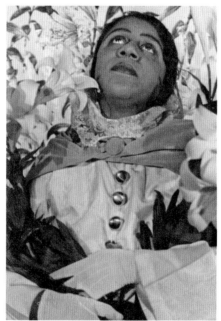

Figures 118–20  Carl Van Vechten, Beatrice Robinson-Wayne as St Theresa in *Four Saints in Three Acts.* 9 March 1934

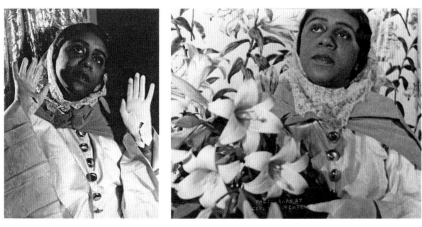

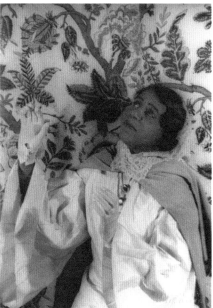

Figures 121—3  Carl Van Vechten, Beatrice Robinson-Wayne as St Theresa in *Four Saints in Three Acts*. 9 March 1934

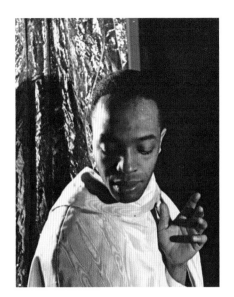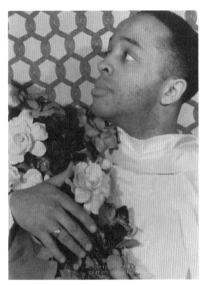

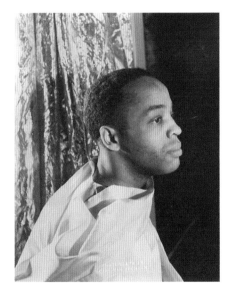

Figures 124–6  Carl Van Vechten, Edward Matthews as St Ignatius in *Four Saints in Three Acts*, 9 March 1934

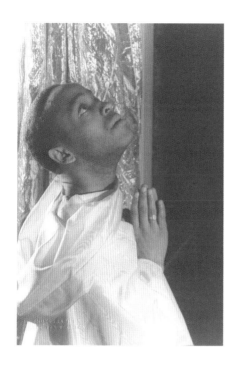

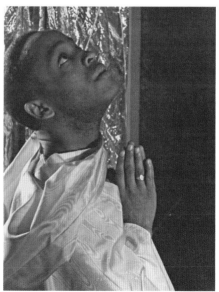

Figures 127–8  Carl Van Vechten, Edward Matthews as St Ignatius in *Four Saints in Three Acts*, 9 March 1934 (variant prints and crops)

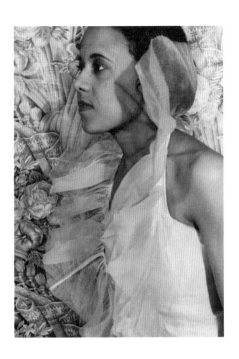

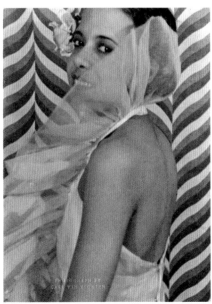

Figures 129–30  Carl Van Vechten, Altonell Hines as the Commère in *Four Saints in Three Acts*, 9 March 1934

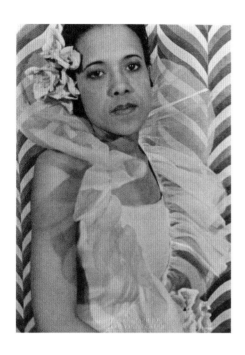

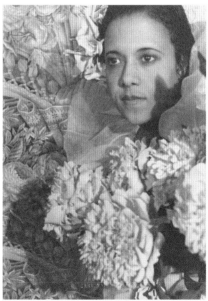

Figures 131–2 Carl Van Vechten, Altonell Hines as the Commère in *Four Saints in Three Acts*, 9 March 1934

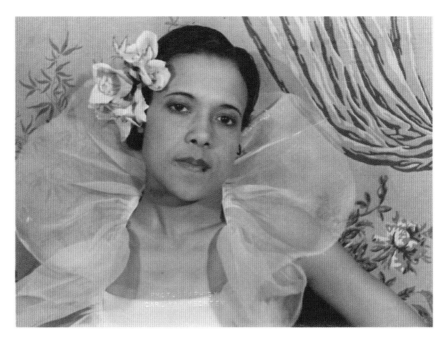

Figure 133  Carl Van Vechten, Altonell Hines as Commère in *Four Saints in Three Acts*, 9 March 1934

# Index